MW01506095

other
conundrums

other conundrums

race, culture, and canadian art

monika kin gagnon

Arsenal Pulp Press Artspeak Gallery Kamloops Art Gallery

OTHER CONUNDRUMS: RACE, CULTURE AND CANADIAN ART
Copyright © 2000 by Monika Kin Gagnon

All rights reserved. No part of this book may be reproduced or used in any form by any means — graphic, electronic or mechanical — without the prior written permission of the publisher, except by a reviewer, who may use brief excerpts in a review, or in the case of photocopying, a license from the Canadian Copyright Licensing Agency.

ARSENAL PULP PRESS	ARTSPEAK GALLERY	KAMLOOPS ART GALLERY
103–1014 Homer Street	233 Carrall Street	101–465 Victoria Street
Vancouver, B.C.	Vancouver, B.C.	Kamloops, B.C.
Canada v6b 2w9	Canada v6b 2j2	Canada v2c 2a9
www.arsenalpulp.com	www.artspeak.bc.ca	www.galleries.bc.ca/kamloops

Arsenal Pulp Press gratefully acknowledges the support of the Canada Council for the Arts and the B.C. Arts Council for its publishing program, and the support of the Government of Canada through the Book Publishing Industry Development Program for its publishing activities.

Book design by Roberta Batchelor & Brian Morgan
Cover image: production still from Dana Claxton's *The Red Paper*, 1996
Cover photo by Cliff Andstein

Printed and bound in Canada

CANADIAN CATALOGUING IN PUBLICATION DATA:
Gagnon, Monika Kin, 1961–
 Other conundrums

 Includes bibliographical references and index.
 ISBN 1-55152-092-3

 1.Minority artists-Canada. 2. Minorities in art. 3. Art, Modern-20th century-Canada.
I. Title.
N6549.3.2000 704.03'00971 C00-910923-4

 ARTSPEAK **Kamloops Art Gallery**

Contents

Artists and Works Reproduced

Acknowledgments

This book came so close to not being published, that my grati-
tude goes first to the publication collaborators who truly
enabled it. To Brian Lam of Arsenal Pulp Press for his initial
and ongoing encouragement, and his insistence that a publish-
ing collaboration was the gateway for the images to happen; to
Susan Edelstein of Kamloops Art Gallery for her remarkable
energy and ability to manifest a project; and to Lorna Brown
of Artspeak Gallery for keeping the ball rolling once it was
motion: sincere thanks to you all for supporting and making
a book like this happen through your work and ingenuity.
Thank you also to designers Roberta Batchelor and Brian
Morgan for taking such care in the book's design.

 The essays in this book were written over the period of a
decade, and so these acknowledgments replace the remarks
that followed some of the essays on original publication. Over
the years, I have had the good fortune of working with many
editors who provided important feedback and colleagues who
provided invaluable information, and so I thank: Renee Baert,
Alison Beale, Jessica Bradley, Brice Canyon, Jeff Derksen,
Marie Fraser, Lesley Johnstone, Laiwan, Lisanne Nadeau,
Judy Radul, Keith Wallace, Mark Nakada and Aruna
Srivastava, Richard Fung, Lisa Steele and Kim Tomczak (at
V Tape), Maija Martin and Carla Wolf (at Video Out), and
Margaret Christakos. Thank you to Susan Crean who cast an
early editorial eye on this manuscript and offered encourage-
ment. Thanks to Michelle Casey, who provided administrative
support and image coordination, and Kathleen Ritter at Arts-
peak Gallery for production assistance. I gratefully acknow-
ledge support from the Canada Council for the Arts and its
peer juries that allowed research, writing, and this publication
to take place; I acknowledge SSHRC in the writing of "Building
Blocks," and support from Concordia University's Faculty
Grants in the preparation of the manuscript.

 Gratitude and respect goes to the many artists and writers
with whom I have had the pleasure of discussions over the

years, and with whom these specific writings conspire: Jamelie
Hassan, Paul Wong, Shani Mootoo, Nhan Duc Nguyen,
Sharyn Yuen, Teresa Marshall, Henry Tsang, Midi Onodera,
Fumiko Kiyooka, Jin-me Yoon, and Melinda Mollineaux.
Thank you also for the permissions to reproduce your works.

These writings are all the richer for the commiseration,
many conversations, and feedback of my friends over the
years, I thank: Lynne Fernie, Lillian Allen, Andrea Fatona,
Minquon Panchayat, Nancy Shaw, Roy Miki, Deena Metzger,
Janine Marchessault, Marwan Hassan, Mina Totino and Stan
Douglas, Ashok Mathur, Denise Oleksijczuk and Ken Lum,
and Leila Sujir. A special thank you to Larissa Lai for the fore-
word. And my gratitude goes to Dana Claxton, whose friend-
ship and ongoing work created the possibility for this book to
happen as it has.

Thank you to my family, Charles, Michiko, Erika and
Yolanda, and Eames. Thank you, Olivia, for your amazing
radiance that illuminates each day. And to Scott McFarlane,
who provided not only extraordinary editing as always, but
more than can be said in theoretical musings, intellectual prod-
ding and support, and companionship: my love and gratitude.

Publication Acknowledgments

"Building Blocks: Anti-Racist Initiatives in the Arts" was published in a shorter form in *Ghosts in the Machine: Women and Cultural Policy in Canada and Australia*, ed. Alison Beale and Annette van den Bosch (Toronto: Garamond Press, 1997). Reprinted with permission.

"Can-Asian, eh? Three Hyphenated Canadian Artists" was published in *Dual Cultures* (Exhibition Catalogue) (Kamloops, B.C.: Kamloops Art Gallery, 1993). Reprinted with permission.

"Go On, Push My Discursive Limits: The Ambivalence of Paul Wong's Video Works" was published in *Paul Wong: On Becoming a Man/Un homme en puissance...* (Exhibition Catalogue) (Ottawa: National Gallery of Canada, 1995). Reprinted with permission.

"How to Banish Fear: Letters from Calgary" was published in *Parallélogramme* 19, no. 3 (Autumn 1993).

"How to Search for Signs of Asian Life in the Video Universe" was published in *Mirror Machine: Video and Identity*, ed. Janine Marchessault (Toronto: YYZ/Centre for Research on Canadian Cultural Industries and Institutions, 1995).

"Lexicon I (for Teresa)" was published in *Métissages* (Montréal: Optica, 1996).

"Lexicon II" was published in *Hyphenation: A Mixed Race Issue of Absinthe* 9.2 (1996).

"Out in the Garden: Shani Mootoo's Xerox Works" was published by the Contemporary Art Gallery, Vancouver, in 1994.

"The Possibilities of Knowledge: Jamelie Hassan" was published in *Jamelie Hassan* (Québec: La Chambre Blanche, 1996).

"Primer for Xenophilic Beginners" was published in *Front Magazine* (Jan/Feb 1994).

Reviews by Monika Kin Gagnon of *In Visible Colours* (discussed in "Building Blocks: Anti-Racist Initiatives in the Arts") appeared in *C Magazine* 25 (Spring 1990) and *Cinéaction* (Fall 1991).

The term *race* already involves us in a dilemma.
　　　　　　　　　　— Albert Memmi, *Racism*

Foreword

by Larissa Lai

In the late eighties and early nineties, a remarkable movement in Canadian cultural politics blossomed. It was marked by a major change in the way that Canadian artists — First Nations, of colour and white — organized and produced art. This was a movement within a particular historical moment, one that began with the recognition of how deeply embedded race and racialization are as forces within Canadian society, and are reflected, among other arenas, in its art production. The moment was also marked by a troubling but fluctuating ambivalence arising from the problematic of constructing identity in reaction to this moment. From the late 1980s to the present, Monika Kin Gagnon was and continues to be one of the most articulate voices documenting, analyzing, and critiquing this history of art production and organization as it unfolds. This volume, which pulls together many pieces written in the varied and changing contexts of the movement as it developed, is important in that it traces the path of a discourse from Gagnon's sharp, analytic, and deeply invested point of view. Gagnon makes no claims to objectivity — the value of this writing is precisely the opposite. It enters the moment and the art practices in a way that is vital, committed, and present. It is all the more valuable because the original articles were published, for the most part, in magazines and periodicals with limited shelf life. Were they not pulled together between these covers they may very well have become lost to posterity, and

we as readers would have been that much the poorer. In marginalized political movements, it is often the case that the writings closest to the ground, the ones that can give subsequent writers, artists, activists, and organizers the strongest sense of what really went on and where to go next, disappear in favour of larger, more general, far less radical versions of the history.

I first met Monika when I took her place in a Toronto panel discussion for the 1991 exhibit *Yellow Peril: Reconsidered*, an exhibit of twenty-five Asian Canadian artists. As a young writer and organizer of colour, that moment was one of incredible excitement, revelation, and activity. The moment, the movement, was marked by a refusal to play by the tenets of assimilationist liberalism, a refusal to play by the multiculturalist rules of the 1970s that demanded we see all Canadians as equal, regardless of background. It broke a taboo against speaking about racial difference. Never mind speaking. It broke the taboo of organizing around racial difference — but with a very important twist. It was a reclamation of those categories that Europe used to colonize the globe, categories that liberalism maintained, while effectively sweeping the names of those categories under the carpet. It was a demand for acknowledgment that liberalism has always kept in perfect working order the power structures previously established through racist colonial ideology. It was a strategy of calling liberalism's bluff. At the same time, it was also a troubled moment. Many of us involved in organizing, creating, and writing to this newly opened arena, understood the dangers of constructing identity in reaction to the racist imaginations of the mainstream. We understood how we were constructed by the mainstream, especially the mainstream press, in doing so. We also understood that the histories of those who banded together to declare the emperor was without clothes were widely disparate, and that much work would need to be done in order to build alliances. And that ultimately, because of its constructed nature, its fraught history, and its roots in the negation of Eurocentric fantasies, that the practice of anti-racist organizing was highly unstable. Nevertheless, its value

as a tool for empowerment was tremendous and could not be denied. Its liberatory effects were so powerful at a practical level that its instability was more than worth weathering.

Two of the pieces in this volume, "Letters to Calgary" and "Building Blocks," speak to five of the most important events in Canadian cultural politics of the nineties: *In Visible Colours; About Face, About Frame*; the activities of the Minquon Panchayat; *It's a Cultural Thing*; and *Writing Thru Race*. Of course, there were others. And there were other takes on these events. But what is particularly valuable about Gagnon's perspective is that she speaks so frankly and directly to the issues at stake without the veneer of politeness or bureaucracy that blanched many voices at that time. She is unapologetic about her support for an anti-racist politic, but at the same time she works to continuously complicate it from within. Her close scrutiny and analysis of the workings of race ideology within events organized to challenge precisely the workings of race is very much of the moment that she writes, and the trace they leave in the present is vital. The incredible power of the moment when Gagnon realizes that the word "race" is absent from ANNPAC's restructuring proposal designed to address precisely that issue, is overwhelming now, when to say "race" seems again such a terribly radical thing. Even the word "equity" isn't used anymore. The word that circulates in hushed tones through offices and art institutions across the country is "diversity." It will be interesting to measure the concerns of this vital volume against those which grow from the groundwork it creates, documents, and critiques.

Gagnon is conscious of writing itself as a representation. The voice and the form of address she employs in each instance is always thought out, is specific to the political and creative needs of the moment and often interacts with the work or the event she writes about. So, for instance, the "Letters from Calgary," addressed to mixed media artist Jamelie Hassan, are written in response to a moment of terrible fracture within the artist-run movement. The political is pulled close to the personal, challenging those who claim a universalist, humanist

approach to interrogate the ideological nature of that which claims itself value-free. By speaking directly to her own experience as a writer of colour within an anti-racist movement, she also throws into question the validity and objectivity of the conventional essay-writing voice. A paradox, certainly, and more vitally, one reflected in the chaos of ANNPAC's collapse at the terrible sight of its own racist image.

The mainstream, shocked and offended by the radical organizing tactics taken up by First Nations artists and artists of colour, expended a lot of hot air bandying about such terms as "reverse racism" and "politically correct," as Gagnon documents in "Building Blocks." The power of white liberalism leaves its mark on all of the events Gagnon discusses, especially on the conference, *Writing Thru Race*. What was largely ignored in the mainstream furore against these events was the incredible fertility of the movement itself to produce work which spoke to concerns around racism — historical, current, and systemic — but which also did infinitely more than that. While many white institutions and the mainstream media were busy ignoring precisely the practices from which they claimed to have been excluded (even though much of the work was publicly available to anyone who cared to look), an incredible period of art production was underway. Gagnon was there, assiduously documenting, critiquing, and querying the work.

"Out of the Garden," her piece on Shani Mootoo's work, originally published in limited edition colour photocopy, is a good instance of this. The text was embedded within floral, paradisiacal borders designed by Mootoo. Gagnon writes of the corpus of Mootoo's work at a time when the artist was working extensively in colour photocopy but was also well underway in a writing project that became the novel *Cereus Blooms at Night*. Among my favourite of the colour photocopy works is a piece, eloquently described by Gagnon in the essay included here, in which Mootoo has collaged an image of her own face onto a partially male, partially female composite of images from a Dr. Marten's underwear box. Gagnon writes, "She is backed by a floral splash, surrounded by an

almond-shaped, unmistakably labial, mirror imaged and mon-
taged, pinkish, mountainous landscape, in turn surrounded by
intricately placed fresh flowers." What is at once charming
and revolutionary about this image is that it is as though,
omni-fertile, Mootoo gives birth to this lush landscape, and
this mischievously gender-fucked version of herself. The past
and future are all reborn out of that catalytic, Edenic moment,
fundamentally altering our ways of seeing history and our
ways of imagining the future. Gagnon's text is framed similar-
ly, though without the "almond-shaped, unmistakably labial"
border. But in the context of the Dr. Marten image, the floral
borders are a sufficient shorthand for a kind of fertile opening.
It might be said then, that Mootoo has given birth to Gagnon's
text. But then the opposite might also be true. Both artist and
writer are conscious of their interrelationship and conscious of
the fantastic fertility of their dialogue with one another, and
indeed with a larger moment and a larger movement of which
they are both creators and created.

There is no question that Gagnon is highly critical of the
work and the moment in which she writes, always trying to
peel back the next layer of logic in the art production and
organizing strategies of her peers. While the strategy of
claiming a racialized identity was an important part of the
movement in its organizing aspects, in its productive and criti-
cal aspects, it was necessary to recognize the strategy as a
strategy, and to recognize identity as continuously fluid and
constructed. In both "How to Search for Signs of Asian Life in
the Video Universe" and in "Can-Asian, eh?" Gagnon queries
the locations and boundaries of the term "Asian," and the sites
of its disappearance and articulation. At an epistemological
level, she reveals the faulty logic of the notion of dual or
multi-cultures; the inaccuracy of the binaries employed at an
everyday mediatized level in discussions of race.

Nonetheless, Gagnon's writing practice is fundamentally
an activist practice. What can this mean within communities
where the notion of translation, the fluid hybrid, is far more
vital than any calcified notion of race purity, inherited and

reclaimed from colonial and imperialist history? One tactic Gagnon effectively and poetically employs is the lexicon, three of which appear in this book. Structurally they use the policing form of the dictionary entry to throw open precisely our belief in the static definability of anything, especially race. Despite their apparently rigid form, there is an irony at work here that is at once serious and playful. Pulling from the vocabularies of botany, animal husbandry, hi-tech, genetics, pop culture, and mythology as well as European race theory of the colonial era, each lexicon is a poetic work that skirts the borders of an uncomfortable discourse that has nonetheless seriously affected people's lives. Her new essay, "Worldviews in Collision," on the work of video installation artist Dana Claxton, pushes this line of inquiry further by questioning the very states of being that give rise to these definitions and to the course of history. What rises from *Other Conundrums*, once the convolutions of the lived experience have been worked through, is the spectre of the hybrid, and the notion of difference as not outside of power, but pressuring it along its borders, from within.

Introduction
An Other Conundrum?

Several years ago, I began gathering the sixty-five essays, reviews, and other writings I had published in Canadian art magazines, exhibition catalogues, conference proceedings, and anthologies, and began imagining the contours of a book. The essays selected for this collection were written from within an eleven-year period of involvement in independent cultural communities in which artists of colour and Native artists' communities self-organized as coalitions, collectives, and caucuses, to stage many, many events including conferences, festivals, screenings, readings, workshops, and exhibitions. *Other Conundrums* corresponds with this explosion and proliferation of work by artists of colour and First Nations artists in Canada during the 1980s and 1990s in the visual arts, film, video, and writing.[1] This book reflects the way in which writing on art and culture became a vehicle to constitute a discourse of cultural difference in many different cultural locations — independent, institutional, and mainstream — riddling Canada's cultural topography as it has for the last decade. I refer to this movement as engaging a cultural race politics, mindful that other terms have circulated which have functioned in different ways to tame by naming this phenomena: multiculturalism, diaspora, cultural diversity, ethnic, and minority art.[2]

When French sociologist Albert Memmi writes "the term *race* already involves us in a dilemma," he is referring to the

1 This wave of artists and writers emerged alongside similar movements in Britain and the U.S., that I will not address here, though it is worth noting the extensive comingling of artists, works, and writings across these contexts. My book is intently focused on Canadian artists and events, which are often excluded in other accounts, although this is not to diminish the important influence of British and American theorizing around these issues. From the U.S., Coco Fusco's *English is Broken Here, Out There: Marginalization and Contemporary Cultures*, eds. Russell Ferguson, et al., and Lucy R. Lippard's *Mixed Blessings: New Art in a Multicultural America*, and *Talking Visions: Multicultural Feminism in a Transnational Age*, ed. Ella Shohat are excellent accounts of race debates in relation to the visual arts; Ella Shohat and Robert Stam's *Unthinking Eurocentrism: Multiculturalism and the Media* examines film and video production. From Britain, *Disrupted Borders: An Intervention in*

biological and social dimensions of race; that is, how race emerged as a nineteenth-century instrument of social control validated by so-called scientific and biological racial theories of difference.3 My sense of the contemporary dilemma is that naming racism's operations means racializing oneself and others within the very terms and operations that have historically enabled racist discourse to proliferate. Many artists and writers have alluded to this double bind of cultural race politics, and their insights into this very problem are quoted within these pages. My use of conundrum (or my adaptation of Memmi's dilemma) is to employ a term that retains the irresolution of the double bind, and to function within its incommensurability. Rather than Memmi's "dilemma," then, something approaching poet Jam Ismail's "oolemma," much more than a dilemma of two parts. The "conundrums" of this book's title therefore acknowledges the contradictory ways in which race and identity figure in our cultural landscape. The book's title borrows from my published conversations with Vancouver artist, Jin-me Yoon, in her catalogue, *between departure and arrival*. Conundrums, there, because we happily ended with more questions than we began with. Conundrums, here, because as these collected essays demonstrate, there are no easy or prescriptive solutions to the circulation of cultural, racial, or cosmological difference in the social sphere. The riddle is engaging with these crises of representation and the contradictions of naming.

Identity and representation are key terms that recur throughout these essays. Identity politics emerged from the post-World War II civil rights movements and can be simply defined as the self-naming and self-identification of individuals and communities around a common identity category in order to make a political intervention.4 A cultural politics of difference emerged from these earlier identity politics and can be distinguished by a more articulated concern for representation and difference across different identity communities.5 As I use the term here, cultural race politics specifically refers to processes of self-identification and the self-organization of

(note 1 continued)
Definitions of Boundaries, ed. Sunil Gupta, Kobena Mercer's *Welcome to the Jungle: New Positions in Cultural Studies*, and *The Fact of Blackness: Frantz Fanon and Visual Representation*, ed. Alan Read, as well as the journal *Third Text*, are representative of how these discussions have developed in a British context.

2 Processes of naming enact different relations to social power. For a comprehensive discussion of terms in relation to racial and cultural difference, see Ella Shohat and Robert Stam's *Unthinking Eurocentrism: Multiculturalism and the Media* (New York: Routledge, 1994), especially the qualification of their term, "polycentric multiculticulturalism," 46-49.

3 Albert Memmi, *Racism* (Minneapolis: University of Minnesota, 2000), 6.

4 A history of identity politics in a broader social frame is engaged by Henry A. Giroux, "Living Dangerously: Identity Politics and the New Cultural Racism,"

MONIKA KIN GAGNON

Native artists and artists of colour into communities, with the goals of making interventions in the larger Canadian cultural domain. As opposed to the earlier civil rights movements, the cultural politics of difference do not necessarily have the state as a focus of intervention. The struggles against various state apparatuses in the earlier movements shifted into broader struggles over issues of representation.

The site of representation has always been integral to the cultural politics of difference. For feminists, this has meant addressing the various modalities of systemic sexism. For queer communities, this has meant tackling the biases of heterosexism and homophobia. And for communities of colour and Native communities of artists and writers, this has meant combatting a systemic racism that is in a continual process of mutation. This book is about race. At issue is visibility, visuality, and power, and what is often referred to as a politics of knowledge; it problematizes who defines and determines cultural value.

These cultural politics identify and contest the numerous sites that constitute the economies of aesthetic value. Representation, in this sense, is understood in its multiple meanings. Aesthetic re-presentation is the process and products of making signs in various media such as art, literature, film, and video. It also refers to discourses or systems of knowledge, such as that of history, or education. Further, a politics of representation suggests an ideological dimension to images, texts, and discourses: representations do not simply "communicate" or "express" ideas, but rather are also "constitutive," in the sense that they contribute to the formation of subjectivities; they are ideological, in the way they privilege dominant values of a society. Representation can also be understood as political representation, making reference to how citizens' interests are acted upon by designated individuals.

Artistic meaning is produced at a variety of inter-related sites that include the production of artworks, as well as their circulation and evaluation. The ways in which issues of race and cultural identity intersect with this economy is highly

(note 4 continued)
in *Between Borders: Pedagogy and the Politics of Cultural Studies* (New York: Routledge, 1994).

5 See *Out There: Marginalization and Contemporary Cultures* for a sense of the coalitions of cultural politics of difference across feminist, queer, and racialized identifications.

specific and often nuanced. A historical consideration of femi-
nist interventions in the arts, as well as gay, lesbian, and queer
interventions into the cultural sphere over the last thirty years
usefully highlights how this configuration of art and identity
has intervened into the economy of value that constitutes aes-
thetic meaning. At its simplest, feminist artists in the 1970s
identified themselves as women within patriarchal cultures,
critically asserting that men were not only the majority pro-
ducers, but had this status because they were the gatekeepers
of art in every sense. In response, this generation of feminists
set about forging self-actualized spaces for women artists and
networks that validated the process and content of their works.
What is now decades of feminist production and analyses of
the cultural field has demonstrated the multi-faceted ways in
which male privilege was historically asserted and maintained,
and the multi-faceted ways in which this resulted in the margin-
alization of women's artistic production. With similar goals,
gay, lesbian, and queer communities self-organized to enable,
develop, and validate the production of gay, lesbian, and
queer artists.[6]

The cultural process further encompasses exhibitions, pro-
gramming, and festival screenings, the question for a politics
of difference being: Who is deciding what to exhibit and where?
The sustaining fields of criticism, catalogue writing, conferen-
ces, and art history form yet another level of publicity and
legitimation (who is writing or speaking, about what and
where?). In Canada, public funding of culture through the
Canada Council for the Arts, as well as through support from
provincial and municipal bodies, has produced yet another
sanctioning filter through which certain artists, exhibition
practices, historians, critics, and institutions are financially
supported by peer assessment juries. In fact, in many ways
because of Canada's public funding of culture, it could be said
that the challenges of equitable political representation in the
cultural process have come to the fore. The Canada Council
for the Arts has notably undergone dramatic changes concern-
ing cultural equity over the last decade, changes that have been

6 For an account of feminist cul-
tural politics in the arts, see *Talk-
ing Visions*, ed. Ella Shohat, Lucy
Lippard's *The Pink Glass Swan:
Selected Feminist Essays on Art*,
or in a Canadian context, *Work in
Progress: Building Feminist Cul-
ture*, ed. Rhea Tregebov. For gay,
lesbian, and queer cultural poli-
tics, see *How do I Look: Queer
Film and Video*, eds. Bad Object-
Choices and *Queer Looks: Per-
spectives on Queer Film and
Videos*, eds. Martha Gever, John
Greyson, and Pratibha Parmar.

7 The Canada Council for the
Arts' response to the needs of
aboriginal artists and artists of
colour with regards to its man-
dates and funding programs has
now been evolving for almost a
decade. For an early account of
the activities of the Advisory
Committee to the Canada Coun-
cil for Racial Equality in the Arts,
see Richard Fung's "Working
Through Cultural Appropriation,"
Fuse vol. XVI nos. 5/6 (1993):
16–24. The Council also regularly
releases published reports that
evaluate the effectiveness of

administrative, organizational, and ideological concerning its definitions of what constitutes the nation's culture.7 Canada's official state Multiculturalism represents yet another policy level that has impacted on artists of colour and aboriginal artists.8

It is an attentiveness to issues of representation that circulates in the artists' works and events I discuss; they engage hybrid textual practices and conceptual approaches as a means to effecting representational, and political, innovation. The essays gathered here engage some of the community practices and artists' works that have explicitly explored cultural identities and their formation within Canadian culture and history.

I wouldn't even pretend to be inclusive in this regard, as I had but a glimpse from my vantage points in Toronto in the 1980s, and then Vancouver, until I moved to Montréal in 1998. There are some markers worth noting that won't emerge in the rest of the book. The 1990 group exhibition, *Yellow Peril: Reconsidered*, was one of the initial large group shows staged under the rubric of deliberately racialized identities. Organized by video artist Paul Wong under the auspices of his On Edge Productions, the show included twenty-five artists working in photography, film, and video; it travelled to six Canadian cities and was accompanied by a catalogue and small panel discussions at exhibition *vernissages*. *Self Not Whole* and *To Visit the Tiger* brought forward the works of Chinese Canadian and South Asian Canadian artists, respectively, in Vancouver, where the interdisciplinary *Racy Sexy* also took place. The exhibitions *Land, Spirit, Power* and *Indigena* took place at the mainstream National Gallery of Canada and Ottawa's Canadian Museum of Civilization in 1992, exhibiting many contemporary Native artists' work. Dozens of smaller exhibitions, including individual artists' shows, also occurred across the country, particularly at artist-run centres. *Race and the Body Politic* took place in the Art Studio Program at the Banff Centre in 1993, bringing together dozens of artists of colour and First Nations artists for the summer residency;

(note 7 continued)
their cultural equity mandates, most recently in June 1999. See also M. Nourbese Philip's "The Multicultural Whitewash: Racism in Ontario's Arts Funding System," in *Frontiers: Essays and Writings on Racism and Culture* for an analysis of racism in a provincial cultural funding organization, the Ontario Arts Council.

8 For a detailed description of the development of multicultural policy, see Audrey Kobayashi, "Multiculturalism: Representing a Canadian Institution," in *Place/Culture/ Representation*, eds. James Duncan and David Ley. For a recent critique and overview of published literature on Canadian multiculturalism, see Himani Bannerji, *The Dark Side of the Nation: Essays on Multiculturalism, Nationalism and Gender.*

As Public as Race, three performances by Paul Wong, Margo
Kane, and James Luna took place during the residency at the
Walter Phillips Gallery and included a publication. Desh
Pardesh (founded in 1989) organized interdisciplinary confer-
ences that continue to take place in Toronto on an annual basis.
The South Asian Canadian quarterly, *Rungh*, also emerged
from this period, while special "race" issues of journals and
magazines proliferated (*Screen* [1988], *Take One* [1994],
Border/lines [1993], *West coast line* [1993], for instance, while
Fuse, *Fireweed* and *Third Text* continued to deal with these
issues in art in an ongoing manner). The occasion to self-
explore, celebrate, and validate cultural identities that had
been marginalized and devalued had clearly found a critical
mass. This book explores some of these occasions as they
emerged.

Other Conundrums is organized in several clusters. The
writings take the form of different engagements with art and
culture: descriptive accounts of various events, reflective and
theoretical investigations of issues concerning cultural differ-
ence and hybridity, and critical writings on individual artists
and group exhibitions.

"Building Blocks: Anti-Racist Initiatives in the Arts" and
"How to Search for Signs of Asian Life in the Video Universe"
were both commissioned for book anthologies. They reflect
and consider the strategies that race identity politics was
deploying in the early 1990s. The first is an amalgam of
several essays I had written on some nationally organized
anti-racist initiatives that I had attended and participated in.
"How to Search..." was written for the book *Mirror Machine:
Video and Identity*, edited by Janine Marchessault, and was the
result of my own decision to write about Asian Canadian video
artists' work. In both essays, self-representation, racialized
categories, and communities develop into a broader problema-
tizing about meaning and interpretation: in practice, the possi-
bilities of a shared politic gave way to crises of representation
in which the very conditions of how to define community and

26

create disruptive strategies were themselves undergoing scrutiny.

"Can-Asian, eh?" was written for the exhibition *Dual Cultures* at Kamloops Art Gallery in 1993, organized to celebrate the city's centennial anniversary. It explores the theme of cultural hybridity in the works of Vancouver-based artists Sharyn Yuen, Nhan Duc Nguyen, and Henry Tsang and unravels presumptions about the notion of "dual cultures." The conundrums of the hyphen are explored conceptually as that which unite but underline an initial separation; this is emphasized in a visualizing of the hyphen in Asian-Canadian throughout this essay, though not elsewhere in the book. Rather than celebrating multiculturalism in an uncritical manner, this essay explores how these works unpack the repressions of specific Canadian histories, particularly in their hybrid, rather than multicultural, forms. While the term "cultural hybridity" has undergone considerable use in the last decade (sometimes discarded as ineffectually vague along with other terms such as "post-coloniality" and "post-modernism"), I would propose that its etymological complexity exhibits the contradictory qualities that continue to make it both provocative and useful. The writings on Shani Mootoo, Teresa Marshall, Jamelie Hassan, and Paul Wong were selected from many essays I have written over the years for the exhibition catalogues of individual artists. These artists' works also deal with themes of cul-tural identity and hybridity in a variety of ways as the essays themselves explore.

"How to Banish Fear" and three short "lexicons" are more experimental in form. The structure of these writings emerged as solutions to the complexity of ideas I was reflecting on. "How to Banish Fear" was a formidably difficult article to write, following fast on the heels of the anti-racism initiative, Minquon Panchayat caucus, that radically transformed the long-standing artist-run centre organization, ANNPAC/RACA. The circumstances that led to the fracturing of the organization are described in more impartial description and detail in the preceding essay, "Building Blocks." These two essays could be

considered companion works, in that they address the same incidents, but from phenomenally different approaches. The personal voice of the letter structure allowed me to dispense with the niceties that often gloss racist confrontations, allowing me to unpack the highly personal impact of such confrontations.

My fascination with lexicons is their interpretive structure; as a form they suggest explanation, cultural and ideological translation. Through a word's etymology, the history of a word's formation and its use, one can make apparent the social conditions surrounding their usage — like race, for instance, or hybridity. When and why do these actually emerge as words, and what are they designated to refer to? As explicatory translation devices they also make obvious when different knowledge systems collide. I use the lexicon in writing about Dana Claxton's video installations, written for the occasion of this book. Her works and this essay consider how aboriginal knowledges can be brought forward into the present through contemporary art while retaining their groundedness in traditional practices.

Rather than look back at these many events and exhibitions from my current vantage point, I wanted these essays to speak from the contexts in which they were originally written. This meant accepting that certain ideas and critiques emerged from the specificity of particular cultural moments, regardless that I might write, or even think about them differently now. I have left these essays largely unedited, except in the most minor ways to make this book cohere. There are also many postscripts or afterwords that might have updated these essays or elaborated the aftermaths of particular cultural events. But, once again, this seemed to be another book, one that was retrospective and would have different, more evaluative, types of demands. Yet it is not as if the impacts of some of these events ended where my writing began. Quite the contrary. The film and video festival, *In Visible Colours,* and the ad hoc caucus, Minquon Panchayat, had dramatic ramifications when the

organizations in which they took place took account of their complicities with systemic racisms, though I do not extensively address this in "Building Blocks" where they are discussed. The Vancouver women's artist-run centre, Women in Focus, was involved in a lengthy and divisive court case concerning the profits made from *In Visible Colours*, and the centre eventually closed as a consequence. The national caucus, Minquon Panchayat, dissolved unceremoniously along with its host, ANNPAC/RACA, while a local Calgary Minquon Panchayat continued to thrive and produce exhibitions and events.[9] The banners from Henry Tsang's *Utter Jargon* (1993) taken up in "Can-Asian, eh?" were re-mounted at the Kamloops Art Gallery when its new building opened in 1998. The banners' explicitly racialized language from the early twentieth-century allegedly offended Kamloopians, as the City of Kamloops Race Relations Committee and Anti-Racism Committee complained in a published open letter. The gallery found itself mired in public debates about the alleged "responsibility" of public art in relation to representations of race and racism that are still ongoing.[10] Precisely such contestations around racialized language and history demonstrate the importance of artistic production as a site for retrieval, exploration, and interrogation. In recovering chinook jargon, an entwined set of cultural relations re-emerges charged with racialized power embedded within the language itself. A racist history of place resurfaces, one that some would rather expunge, offering itself as a site of reflection for understanding cultural exchanges in the present.

The initial compilation of this book was partly a personal process, guided by a need for revisitation and provisional closure around a body of thinking and writing that encompassed fifteen years. Yet this moment of anthologizing also began to coincide with an ostensible transition in Canadian cultural art politics, particularly concerning issues of identity and race. This transition is a seeming perception that identity politics is in its twilight years. It is my hope that the documentation and analysis that constitutes *Other Conundrums* proposes that

9 See Ashok Mathur, "Troublemakers in training: notes towards anti-racist (art) activism and taking it to the streets. Calgary," in *Taking it to the Streets* (Toronto: SAVAC, 1998).

10 For these exchanges see various articles published in the *The Daily News, Kamloops* and *Kamloops This Week,* August through September 1998.

identity politics can only be in demise if its impact is understood simplistically, which is to say, in its most essentialized forms. Cultural race politics have often been detrimentally characterized as a homogenous and containable mass or *problem*; one that has to be managed, one that has achieved its goals by virtue of a few token figureheads and government programs, and can now be considered, finally, over and done with. Such characterizations are not simply incidental, as feminist politics would remind us, they must be understood as profoundly motivated from where they emerge. Cultural race politics routinely and unfortunately inspire reflexive responses and denials of racism by those positioned as oblivious to its vivid, day-to-day practices, an obliviousness compounded by the erasures of history. This impulse to will cultural race politics to be over with, I think, has to do in part with the affective dimensions of racism, its deep imbeddedness within historical and cultural formations and the privileges it camouflages. These writings repeatedly emphasize complex identifications rather than rigid identities. And a notion of differences *within* difference. This is exactly to work against and complicate what has often been the reductive and deliberately recuperative portrayal of cultural race politics by mainstream culture and its institutions. These writings hopefully chip away at these defences to offer productively transformative possibilities. I would like to think of cultural race politics as a transformative process. And indeed, around the conundrum of "identity" itself, that it will continue to emerge and re-emerge *because of this process* not as an essence, so much as shifting conjunctures of identifications which must continue to be usefully deployed where and when deemed fit. *Other Conundrums* thus reconfigures this illusive demise of identity politics with the necessity of their incessant future; one grounded in palpable, not obliterated, histories.

Worldviews in Collision: Dana Claxton's Video Installations

INT. PRIESTS CHAMBERS.NIGHT.

WINKTE

(*contemptuously*)

They cannot take away our gods.
Why do they continue to try?

During his lifetime, Oglala Sioux chief, Tesunke Witko (Crazy Horse), persisted in his refusal to be photographed. "Why would you wish to shorten my life by taking my shadow from me?" he is quoted as saying in 1875, explaining his unwillingness to pose for the camera.[1] For Tesunke Witko, the real world was dreamed while the world we live in and earth we walk upon was but a shadow.[2] At issue was a refusal to submit to what he considered the technological violence of the photographic medium. It also speaks to different cosmologies of representation problematizing what (photographic) representations effect when they manifest images. A thread between Crazy Horse's anti-photographic anecdote and Vancouver interdisciplinary artist Dana Claxton's two new video installations, *Waterspeak* (2000) and *The Heart of Everything That Is* (2000), is a nexus of considerations about colliding cultures and technologies. Claxton's works evoke such collisions in their exploration of storytelling. Specifically, in their fragmented allusions to Lakota creation stories and relations to the earth, these installations reconfigure and reflect on

1 Susan Hazen-Hammond, *Timelines of Native American History* (New York: Perigree, 1997, 175.

2 Dee Brown, *Bury My Heart at Wounded Knee* (New York: Henry Holt, 1970), 289.

opposite page
Dana Claxton
Tree of Consumption, 1992
still from performance
grunt gallery, Vancouver
Photo credit: Merle Addison

well-trod tensions in the reception of Native art concerning traditional and contemporary practices. These installations bring the relevance of such stories into the present, and bring forth mediation through storytelling and videomaking as not simply transparent, but as processes in themselves.

To begin, *Waterspeak* and *The Heart of Everything That Is* assume a Lakota worldview. That is, they are produced in part within an elaborate knowledge, belief and value system, nomenclature, and set of cultural references that are particular to Lakota tradition.3 As video installations, these works also intersect with a specific media history and in this particular instance, largely non-Lakota audiences of Artspeak in Vancouver and the Kamloops Art Gallery. Claxton has described her two new works as an attempt to construct a "religious art approach," one that "hybridizes a cultural process of contemporary art-making and traditional knowledge, by creating a site where two seemingly different ways of knowing or being interface."4 These two video instal- lations are shaped from a body of footage originally shot on black and white film and transferred to video that will also be developed into a longer film. In both of these installations, two images are projected as "diptychs": brief, theatrical dialogues between a woman and man are coupled with ongoing loops of, in *Waterspeak*, a blue-filtered image of the flowing Capilano River, and in *The Heart of Everything That Is*, a red-filtered, moving close-up of white stones.

At first glance, Claxton's new video installations seem something of a departure from her previous time-based works.5 Her four early videotapes, *Tree of Consumption* (1993), *The Shirt* (1994), *I Want to Know Why* (1994), and *Buffalo Bone China* (1997), explicitly engage the myriad destructive impacts of European colonialism upon Native cultures and therefore bear witness to the confrontation between Native and non-Native histories. Charlotte Townsend-Gault succinctly described the characteristics of many Native artists' works since the 1980s: "to remember, to condemn, to overturn, to instruct, to translate across cultural boundaries,

3 The Sioux traditionally formed three geographical groups in the Plains and spoke three distinc- tive dialects of the Sioux language, of which the Tetons, or *Titonwan* (who occupied west of the Missouri River on the plains of North and South Dakota and Nebraska) called themselves Lakota (the Dakota and Nakota are the other Sioux dialects). The Lakota, or Western Sioux, are fur- ther distinguished as seven bands or councils: Oglala, Brulé (*Sicangu*), Minneconjou, Sans Arc (*Itazipco*), Two Kettles, Hunkpapa, and Blackfeet. See James R. Walker, *Lakota Belief and Ritual*, eds. Raymond J. DeMallie and Elaine A. Jahner (Lincoln, Nebraska: University of Nebraska Press, 1980).

4 Dana Claxton, "Artist's State- ment," Artspeak Gallery, May 2000.

5 Claxton also works in perfor- mance, many of which incorpo- rate her videos. For instance, Claxton describes *Buffalo Bone China* as an endurance

and yet to withhold translation, to make beautiful things, according to various ideas of beauty, and, sometimes, riotously and discomfitingly, to entertain."[6] Claxton's videos might be understood as retaining several of these attributes at once. *The Shirt* and *Tree of Consumption* address the impacts of American colonialism through *The Shirt's* metaphors of European clothing and symbols of Christianity, and the second tape evokes the environmental devastation effected by the commodification of trees as natural resources. *I Want to Know Why* and *Buffalo Bone China* closely engage aspects of Claxton's family history and the buffalo-hunting Plains Lakota culture that is her matrilineal heritage, as both have been violently transformed by American colonial practices. In Townsend-Gault's schema, these tapes remember, condemn, and overturn. They accuse, perhaps, and also, defy.

The Lakota theologian Vine Deloria Jr. wrote in 1974: "Perhaps the only certainty is that Indians will continue to understand the conflict between Indians and the rest of society at its deepest level as a religious confrontation."[7] Claxton's sense of her own new works as undertaking a "religious art approach" corresponds, I think, to this "deepest level" of conflict that Deloria identifies. We might understand this "religious art" to be a fundamental staging of implicated worldviews extending into all discursive realms which would encompass the political and aesthetic among them. The Lakota scholar Beatrice Medicine has written, "While the English word 'Art' represents a compartmentalization of an aesthetic framework, Lakota world view represents an integration which is difficult to delineate into discrete entities."[8] The historical engagements in Claxton's videos and film suggest the complicated, interwoven territories Claxton's and many other Native artists find themselves simultaneously navigating in their works; political intention and interrogation are entwined in an exploration of the very aesthetic representation and language that have shaped these artists' formations.

Claxton's four early tapes undertake a historical interrogation and critique through a formal experimentation of video's

(note 5 continued) performance in which she smashed fine bone china dishes, which were then incorporated into a video installation. This essay comments predominantly on the videos and films.

6 Charlotte Townsend-Gault, "Hot Dogs, a Ball Gown, Adobe and Words: The Modes and Materials of Identity," in *Native American Art in the Twentieth Century*, ed. W. Jackson Rushing III (New York: Routledge, 1999), 113.

7 Vine Deloria Jr., *For This Land: Writings on Religion in America* (New York: Routledge, 1999), 129.

8 Beatrice Medicine, "Lakota Views of 'Art' and Artistic Expression," *Ablakela* (CD-ROM), (Vancouver: grunt gallery, forthcoming).

materiality. This makes inseparable what is told from the mode of its telling, playing with the veracity of both historical and aesthetic representation. (The distinction here would be the use of conventional documentary forms or revisionist docudrama to engage history.) *Tree of Consumption* utilizes a degenerated video image produced with low-end equipment to accentuate a notion of the degradation of the environment. *I Want to Know Why* adopts the music video form with its rapid cutting and techno-pop soundtrack. *The Red Paper* offers the complexities of these negotiations between historical representation, politics, and aesthetic genres in its forays with theatrical stagings of reversal and parody. In this regard, *The Red Paper* is exemplary of how the aesthetic and political are entwined.

INT.PRIESTS CHAMBERS.NIGHT.

BOUND MAN
What happened to this beautiful island?
What happened to this celestial home?

Textured in grainy 16mm black and white, *The Red Paper* opens with Louis and Young Man costumed in Renaissance Euro-fashion of ruffled shirts, faux ermine, and leather boots. They speak of the invaders' brutality in feeding human flesh to dogs as they look at a white dog licking and gnawing a chunk of raw meat. "Uncivilized, savage, barbaric," they observe in horror, "the invaders are primitive in their thoughts." A neo-baroque synthesized organ soundtrack drones repetitively as candelabras blaze behind them.

Poised against the weight of prevailing "discovery" narratives that have consistently favoured a viewer identification with Christopher Columbus,9 what is initially striking about *The Red Paper* is the film's intertextuality, its layering and pastiche of various cultural codes retelling the arrival of European colonizers. There is a mêlée of cultural stereotypes, more particularly, of Indian stereotypes produced by mainstream white culture. Claxton has Native actors inhabit the "roles"

9 See Ella Shohat and Robert Stam, *Unthinking Eurocentrism: Multiculturalism and the Media* (New York: Routledge, 1994). Especially Chapter 2 "Formations of Colonialist Discourse" in which they discuss the repetitive mainstream tropes of Columbus "discovery" narratives.

of conventional white European Renaissance characters to unsettle, as she has suggested, the ubiquitous playing of Native roles by white actors.[10] Louis, Young Man, Elizabeth, and Winkte comprise a small community that anticipate the onslaught of colonialism with piercing insight. Winkte is the most enigmatic of characters, named after the honoured two-spirit wo/man role in Lakota culture. Here, s/he is a holy and somber priest figure who embodies a duality of Native spirit and Christianity. Bound Man symbolically occupies a European conscience of sorts, literally bound and remorseful throughout.

The Red Paper converses with the vernaculars of experimental film in its cinematographic and montage aesthetics, and in its non-narrative structure. The absence of narrative accounting and specific historical references alter-nately evokes a more totalizing haunting by the legacy of colonialism. Temporally, diachronic chronological history is suspended, as fifteenth-century European dress and theatrical language are featured alongside a brief TV news broadcast on a 1990s Watchman wrist screen. Underlying Claxton's version of events is an insistence that colonialism's effects continue to rupture the present. *I Want To Know Why* similarly interrogates past history from the present moment. Archival photographs of her great-grandmother Mastachila is juxtaposed with the Statue of Liberty and "Indian" visual clichés such as North America's largest stone Indian figure at Indianhead, Saskatchewan. Layered with Russell Wallace's techno-pop soundtrack,[11] Claxton's voice recounts how her great-grandmother was one of 2,000 starving Lakota walking to Saskatchewan in 1877 with Sitting Bull, fleeing the genocidal practices of the U.S. government in South Dakota: "And I want to know why," she roars.

A sense of a haunted present is created by this compression of synchronic history, amplified by a stylized, highly theatrical space within which the film is staged. Composed of sparse interior sets shot with minimal depth, the actors move across the screen and perform exclusively to camera. With these minimal sets (sometimes simply designed with elaborately draped

10 See Jacquelyn Kilpatrick, *Celluloid Indians: Native Americans and Film* (Lincoln and London: University of Nebraska Press, 1999) for a history of such representations in mainstream Hollywood cinema.

11 It is worth mentioning that Russell Wallace has composed original scores for all Claxton's works to date, creating an almost collaborative quality with Claxton's visual style. Wallace's fusions of western and aboriginal electronic musical forms create a distinctive sound that has integrated traditional forms of throat singing, for instance, with synthesizers, electronic sampling, and techno-pop rhythms. See the interview with Wallace in *Chinook Winds: Aboriginal Dance Project* (Banff: The Banff Centre and 7th Generation Books, 1997), 50–58.

fabric, burning candles, and torches), a highly ominous atmosphere creates a landscape which lacks precise geographic or temporal location, but where the threat of invaders and violence lurk just beyond the fortress walls that are the boundaries of the film's world.

In its parodic dimensions, *The Red Paper* achieves more than a mere mimicry of the formal styles of the conquest period: it foregrounds the Eurocentric arbitrariness of signs and signifiers with which the conquest was legitimated. The Native peoples were (mis)named Indians when Columbus mistakenly thought he had arrived in India; misperceived as having no religion, Christian salvation became the colonizers' alibi for expropriations of land and genocide; and among the strange rituals of possession of territory was the ceremonial tossing of sand and the marking of trees in empty gestures diligently documented by accompanying secretaries.[12]

While composed in part by dramatic action and dialogue, the film is not driven by narrative but by fragments of episodes, hints of connections — in the fortress halls, a banquet room, the priest's chambers. Historic facts are symbolically compressed like grenades ready to explode into a litany of detail. In this sense, the distinctly non-narrative approach conspires to critique a realist aesthetic as complicit in the production of Eurocentric history. The protagonists struggle to make sense of the invaders' intentions. "What do they yearn for?" Young Man asks Elizabeth in the banquet hall. "Good God, not gold!" he mocks, as Elizabeth and a group of servants behind them break into laughing derision.

12 See Stephen Greenblatt, *Marvelous Possessions* (Chicago: University of Chicago, 1990), 103, for a description of these arbitrary constructions of colonial signs.

opposite page
Dana Claxton
I Want to Know Why, 1994
Courtesy of Video Out

Black Hills of Dakota (Lakota Version): Paha-Sapa. The heart of everything that is. The centre of the universe.

Black Hills of Dakota (American Encyclopedic Version): Forested mountains rising above the Great Plains in SW South Dakota and NE Wyoming. Harney Peak (7,242 ft/ 2,207 m) is the highest point. Gold mining (begun in 1874) and tourism are chief industries. See also Ward Churchill, "The Earth is Our Mother": "In 1863, a Catholic priest named Jean de Smet, after sojourning illegally in the Black

Hills, reported the presence of gold there.... When Custer, during the summer of 1874, reported that he too had found gold, the government dispatched a commission to purchase the region from the Lakotas while developing contingency plans for a military seizure in the event negotiations were unsuccessful."[13]

As Ward Churchill writes of the political history of the Lakota nation, one encounters the legacy of deceptions by the U.S. federal government protracted since the mid-1800s in its dealings with the Lakota people. With court cases still ongoing since the U.S. government's breaking of the Fort Laramie treaty in 1874, a legal document which explicitly gave the Lakota jurisdiction of the Black Hills only six years earlier in 1868, what can be discerned is the function of highly coded systems of power — and the arbitrariness of the judicial system — that enabled access to the copious gold of South Dakota's Black Hills for more than a century. (Churchill writes that $18 billion worth of gold had been mined since 1874 by the Homestake Corporation from one site alone.[14]) It is within these Native and immigrant relations that Crazy Horse had refused to sit for the white man's camera; following what is known as Custer's last stand in 1876, Crazy Horse was killed in captivity in 1877. Claxton's *The Heart of Everything That Is* makes no explicit reference to this ongoing political and legal history. But neither does she name the Black Hills, either.

Dressed in elegant, contemporary wardrobe, a man and woman stand motionlessly contemplating. As in *The Red Paper*, a sparse but opulent theatrical set is created with hanging draperies, as the camera dollies around the actors and a bundle cradled atop a six-foot tripod constructed of three branches. A double superimposition layers the opening image as the camera encircles them. In inter-cutting close-ups, the mythic First Beings, Woman and Man speak:

13 Ward Churchill, "The Earth is Our Mother: Struggles for American Indian Land and Liberation in the Contemporary United States," in *When Predator Came: Notes from the Struggle for American Indian Liberation* (Littleton, Col.: Aigis Publications, 1995), 135.

14 Ibid., 140.

opposite page
Dana Claxton
The Red Paper, 1997
installation view
Walter Phillips Gallery, Banff
Photo credit: Don Lee
Collection of the Vancouver
Art Gallery

I looked up and saw below
I looked down and saw above
star shone bright in the night
star so full of light
star shifted and moved in flight
star shone, oh so bright
dancing singing star at night
star fell onto earth that night

and star landed here that night
from the star that are from the sky came the stones with...

A close-up of the man's hand reveals a small, perfectly round white stone. The white stones are then intercut in a dollying shot, and solely compose a second projected image which is filtered through a deep red tone.

The actors commune and share a known story of the stars in the sky and their falling with stones to the earth; they share the familiarity of this story. It is performed, a celebration of this supernatural wonderment of the stars and stones that the actors recount. The woman stares into camera, then as if ritually, gestures her arms toward the stars and sky, as the camera performs acrobatics of simultaneous dollying and zooming, lights fading behind her to frame her in dramatic silhouette.

Townsend-Gault has described how two Native artists have used Native languages in their work and purposefully withheld translations into English. The first is Edgar Heap of Birds' 1982 spectacolour electronic billboard piece in New York's Times Square, which displayed the word *vehoe* in the Cheyenne language, meaning spider and referring to white man, "*vehoe* trap you." Also quoted is Jimmie Durham's response to an interviewer's query about the limited viewer access to his use of Cherokee in a sculptural assemblage: "What I want them to know is that they can't know that. That's what I want them to know."[15] In these instances, the deliberate withholding of translation from Cheyenne and Cherokee into English functions as a vexation device for those

15 Townsend-Gault, 126.

unfamiliar with these languages. This is, as Durham expresses, the precise point: that you don't know, or in his words, that you *can't* know.

If one is unaware that "the heart of everything that is" of Claxton's title, and of which the woman speaks, is a sacred centre of Lakota cosmology, there may be other elements that are also somewhat enigmatic. Like Heap of Birds' and Durham's use of Native languages, Claxton's installation inspires questions about cultural translation and difference. But if Heap of Birds' and Durham's works refuse English translations as a calculated confrontational mechanism, Claxton's work stages an encounter that yields to a viewer's possibility of a future knowing. This happens in a strangely compelling way: the theatrical and performative qualities of the dialogue allude to a profundity that is at once, emotional, and therein inviting. Pathways opened up by Claxton's works are created through the viewer's ability to elaborate the references to Lakota belief systems, or a viewer's willingness to encounter this affective seduction with a possible bewilderment about the fragmented allusions to Lakota perspectives. One may be aware of the significance of "mysterious stones" in the Lakota tradition. One may read the bundle as a sacred one, or as the *wakan* (sacred) bundle brought by White Buffalo Woman to the Lakota 2,200 years ago. One may know the Lakota cosmology that situates the stars in an elaborate mirror relationship to the earth — as above, so below — which situates the Black Hills at the centre of the universe. And when Woman speaks:

> *I looked around and I saw the heart of everything that is....*
> *I felt free...I felt freedom*

we sense this to be *wakan* because the theatrical and performative overtures have coded this language with a sense of the sacred. These theatrical attributes in *The Heart of Everything That Is* give way in *Waterspeak*, to a more cinematic quality of technical effects that bring mediation itself, the mode of telling, to the foreground with the teachings themselves.

In their *Waterspeak* dialogue, Woman bestows knowledge of the earth to Man. He concurs with these teachings that recognize wind and water as bestowing a wisdom to be shared, to be passed on. Lakota legend as told here by John Fire Lame Deer recounts how a *lila wakan stranger*, Ptesan-Wi, White Buffalo Woman, visited the Lakota bringing a sacred pipe and ways of living.

"Someone sacred is coming. A holy woman approaches. Make all things ready for her." So the people put up the big medicine tipi and waited. After four days they saw the White Buffalo Woman approaching, carrying her bundle before her. Her wonderful white buckskin dress shone from afar. The chief, Standing Hollow Horn, invited her to enter the medicine lodge. She went in and circled the interior sunwise. The chief addressed her respectfully, saying "Sister, we are glad you have come to instruct us."

She told them what she wanted to have done.... Halting before the chief, she now opened the bundle. The holy thing it contained was the chunupa, the sacred pipe. She held it out to the people and let them look at it. She was grasping the stem with her right hand and the bowl with her left, and thus the pipe has been held ever since.[16]

16 "The White Buffalo Woman," as told by John Lame Deer, in *American Indian Myths and Legends*, eds. Richard Edoes and Alfonso Ortiz (New York: Pantheon Books, 1984), 49.

In Black Elk's account, White Buffalo Woman then holds the pipe to the heavens and says, it is said:

"With this sacred pipe you will walk upon the Earth; for the Earth is your Grandmother and Mother, and She is sacred. Every step that is taken upon Her should be as a prayer. The bowl of the pipe is of red stone; it is the Earth. Carved in the stone and facing the center is the buffalo calf who represents all the four-leggeds who live upon your Mother. The stem of the pipe is of wood, and this represents all that grows upon the Earth. And these twelve feathers which hang here where the stem fits into the bowl are from Wanbli Galeshka, the Spotted Eagle, and they

represent the eagle and all the wingeds of the air. All these peoples, and all the things of the universe, are joined to you who smoke the pipe — all send their voices to Wakan-Tanka, the Great Spirit. When you pray with this pipe, you pray for and with everything."[17]

A digitized image of waterfalls (washed-out 16mm film transferred to video, shot off a monitor, and then further processed) intimates falling water which is intermittently heard. Superimposed behind this descending screen of water are interchanging close-ups of Woman and Man whose images fade in and out as they speak, their voices echoing and overlapping. As with *The Heart of Everything That Is*, which doesn't insist on a political or legal history of the Black Hills, the woman's status as White Buffalo Woman, and her *wakan* standing are not explicitly announced either. A slow drumbeat, synthesized piano, and chanting male voice compose a soundscape. Twinned with this dialogue is a filtered vibrant blue image of the flowing Capilano River.

A shuddering ensues, created by the circularity of music and dialogue, their echoing, and the transience of fading and superimposed images that are in continual motion. This sense of shuddering persists as the teachings being described are themselves about teachings and their future telling, how they will be passed on:

17 Joseph Epes Brown, ed. *The Sacred Pipe: Black Elk's Account of the Seven Rites of the Oglala Sioux* (New York: Penguin Books, 1971), 5-7.

WOMAN MAN
 I listened as water spoke
And as you listened what did you hear?
Eagle soars above you now
 And when I listened
You have learned the wisdom
 And when I listened
 I was taught the ways
You must show them how
 And if my words fall upon broken ears
 I will do my best so they don't retreat

When you reach the place where they taunt
 I will do my best so they don't retreat
Remember
They do not know the knowledge
 You have spoken
The wisdom wind has told
 You have spoken
 I have listened with wounded heart
 And I have listened with wounded heart...
Wind has spoken, they must listen
 And I will tell them
 As I have been told
They must listen to water speak....
 And I will listen to water speak....
For water never, never lies....

In its telling of re-telling, and the obstacles that may be encountered in this process, *Waterspeak* both embodies the teaching of water and wind's wisdom, and also, how this wisdom is taught and passed on as a way of learning. Woman's teaching about how to look and see, is also about how you learn and teach, how knowledge is passed so that culture can maintain itself. *Waterspeak*'s title responds to its siting at Artspeak, staging it within this specific gallery; it speaks these Lakota teachings within a discourse of art and aesthetic value. The space created by *Waterspeak* is thus an engagement between traditionally-derived aspects of (aboriginal) culture(s) and their emergence into "contemporary" practices and cultures — how waterspeak as sacred Lakota teachings, are relevant to Artspeak Gallery and contemporary "artspeak."

In the close of her essay, Beatrice Medicine gives voice to some artists' views on art. The Dakota artist, Oscar Howe "viewed art and philosophy as *ini,* 'to live' — 'in art I have realized part of a dream,'" she quotes. Douglas Fast Horse refers to *Wolanota ki,* meaning "art, music, aesthetics, a way of life." The Hunkpapa ritualist, Joe Flying By, "uses *wiconi* to include the above categories, the expressive elements of

Lakota culture."[18] In such a spirit, Claxton's digitized water-fall might not be seen as an unmediated, romantic representa-tion of nature, but one that straddles the complex conjuncture of cosmological differences in relation to nature. And at this conjuncture, traditional stories come into the present and thrive, differently, perhaps, but they come.

18 Beatrice Medicine, "Lakota Views..."

Lexicon II

American Beauty a variety of hybrid, perennial red rose.

Amerasians, meaning the offspring of American serviceman and their Filipina entertainers [sic], also known as "souvenir babies"; prices as low as $25 to $200 depending on their racial origins and physical attributes.

Can-Asian, eh?

cyborg (sibôrg) *n.* [cyb(ernetic) org(anism)] a hypothetical human being modified for life in a nonearth environment by the substitution of artificial organs and other body parts.

eu·phen·ics* (yoo feni'iks) *n. pl.* [with sing. v.] [coined (1963) by Joshua Lederberg, U.S. Geneticist <*eu-* + phen- (as in *phe-notype*) + *ics*, after *eugenics*] a movement seeking to improve the human species by modifying the biological development of the individual, as through prenatal manipulation of genes with chemical agents.

Eurasian, *n.* a person who has one European and one Asian parent, or a person who is generally of mixed European and Asian descent; of people of both Europe and Asia.

half or double colour, or is it: of colour and pallor?

half-breed* (-bred) *n.* a person whose parents are of different races; esp., an offspring of an American Indian and a white person —*adj.* half-blooded. Sometimes regarded as a hostile or contemptuous term *See* Maria Campbell, Cher.

heterosis (het'er o'sis) *n.* [*heter(o)* + *-osis*] (botany) a phenomenon resulting from hybridization, in which offspring display greater vigor, size, resistance, etc. than the parents — het'er·ot'ic (-ät'ik) adj.

hybrid *n.* half-breed, half-blood, half-caste (**mankind, crossing**) 3. Linguis. a word made up of elements from different languages, as companionway *See* M.M. Bakhtin. Described by Webster in 1828 as "a mongrel or mule; an animal or plant, produced from the mixture of two species" [my emphasis]... first recorded use in the 19th century to denote the crossing of people of difference [sic] races is given in the OED as 1861...the belief there could be such a thing as a human *hybrid*.

hybridity as a cultural description will always carry with it an implicit politics of heterosexuality...

hybrid vigor same as *heterosis*.

"if only you were a regular black."

mestizo, mestiza, from Gr. *symmitkos*, commingled.

Mi'notaur *n.* (Gk Myth.) bull-headed man kept in Cretan labyrinth and fed with human flesh. [ME f. OF Lf. GK *Minotauros* (*Minos*, legendary King of Crete, husband of Minotaur's mother, + *tauros* bull)].

Mixologist* (mik säl'e jist) *n.* [*mix* + *-ologist*, as in biologist] [Slang] a bartender.

on ne possede aucune preuve de l'existence de races pures.

Picasso's fifteen plates in his *Vollard Suites* of 1930-37, his own creative interpretation of the minotaur as man's animal nature freed from the restrictions of his analytical intellect. Some ten years later, André Gide's *Thésee* appeared with its vivid impressionistic pictures of the languors of the Minoan court, a labyrinth of intoxicating pleasure and a minotaur of animal beauty and erotic fascination, which recalls the young Tunisian Negroes and their uninhibited charms which for Gide was an escape into

"sexuality is the spearhead of racial contact"

This son infected with mortality reminded her of the only sin of her divine younger years; she had slept with a man without taking the banal precaution of changing him into a god.

* Denotes Americanism

Sources

Brontë, Emily, *Wuthering Heights* [1847], ed. William M. Sale (New York: Norton, 1972), 54, quoted in Robert J.C. Young, fn 2, p. 183.

Grand Larousse Encyclopédique

Oxford English Dictionary, 2d ed.

Radice, Betty, *Who's Who in the Ancient World* (New York: Penguin, 1987), 166.

Roget's Thesaurus

The Vancouver Sun

Webster's New World Dictionary

Young, Robert J.C., *Colonial Desire: Hybridity in Theory, Culture and Race* (New York: Routledge, 1995), 5-6, 25.

Yourcenar, Marguerite, *Fires* (New York: Farrar, Strauss and Giroux, 1981), 14.

Building Blocks:
Anti-Racist Initiatives
in the Arts

Instead of relying on the 'kindness of strangers' to open doors
for us, the conference was part of a process of strengthening
and opening the doors ourselves.
 — Mina Shum on *About Face, About Frame*

Writing Thru Race
closing plenary
Vancouver, 1994
Photo credit: Neil Lucente/
Victor Wong

I'm not sure we want to go through that door. Our task may be
something like ripping off the door.
 — Dionne Brand at *Writing Thru Race*

ANNPAC is a house that simply must be rebuilt.
 — Lillian Allen, "Transforming the Cultural Fortress"

Four comparable cultural events that occurred between 1989
and 1994 are illustrative of some strategies of political
activism concerning issues of race and cultural difference in
Canadian cultural production. *In Visible Colours; About Face,*
About Frame; It's a Cultural Thing / Minquon Panchayat; and
Writing Thru Race could be characterized as nationally based
in intent, and occurring within alternative cultural networks.
Although these events took place within different disciplines
— film and video production, visual arts, and writing — they
are essentially related in having been initiated and organized
by people of colour and First Nations peoples working to
address racism and cultural inequity in the contexts of
national cultural organizations.

As it is impossible within this essay to comment fully on each of these events, I have generally contented myself with briefly describing and addressing specific initiatives, strategies, and conflicts in each. With the exception of *In Visible Colours*, these events were developed in relation to already established cultural organizations, alternative or otherwise. They all functioned within a strategy of identity politics: that is, these events were organized by and for artists or writers, self-identified as First Nations or of colour, who presented a challenge to white-dominated cultural organizations.[1]

Providing "access" to excluded or underserved communities identified by race, gender, or sexual orientation characterizes the dominant rhetoric of most cultural organizations tackling issues of gender and cultural equity. This essay considers the implications of negotiating as self-defined communities of colour with largely all-white organizations. I attended *In Visible Colours*, and was a participant in the three other events which are discussed here. My experience with the Minquon Panchayat/ANNPAC in particular proved instructive in several ways. It demonstrated how an equity rhetoric which ostensibly invites diversity and embraces change can continue to maintain a paternal approach and leave existent relations of power intact. It revealed how equity enters the vocabularies of institutional bureaucracies and organizations as a response to pressures from communities self-organizing to challenge their exclusion from the resources and discourses of mainstream culture. But it also revealed that the way in which this new vocabulary is practically interpreted is another matter. Measures such as the introduction of anti-racism workshops focus on an organization's own needs for awareness and education but effectively operate as delaying tactics. Dionne Brand has described:

> Notions of access, representation, inclusion, exclusion, equity, etc., are all other ways of saying "race" in this country. So it's made it comfortable to talk covertly about race in this country without saying that we live in a deeply

1 It would be productive to consider the specificities of the different media and their contexts of production and dissemination (i.e., writing and publishing vs. independent film, etc.). It would also be interesting to examine the historical trajectories of these organizations and their inception within broader social and cultural contexts.

2 Dionne Brand, "Notes to Structuring the Text and the Craft of Writing," *Front* 6, no. 1 (September/October 1994): 13.

3 Lillian Allen, "Transforming the Cultural Fortress: Imagining Cultural Equity," *Parallélogramme* 19, no. 3 (Autumn 1993): 52.

4 Ahasiw Maskegon-Iskwew made these remarks in an unpublished paper delivered at *Parallel Tracks*, one of two preconference panel discussions organized by the Programming Committee and held in Vancouver prior to *Writing Thru Race* on March 28, 1994. See Scott McFarlane's "Preconference Events: 'Passing the

racialized and racist culture which represses the life possi-
bilities of people of colour.[2]

I would contend, however, that the terms of negotiation are
rapidly shifting as social inequality is revealed to insidiously
permeate all levels of the language, structures, and procedures
that allow these organizations to operate. As Lillian Allen has
said:

> Those of us who do this [equity] work are about to keel
> over from the censorship of tact, constantly negotiating the
> infested waters of white guilt, liberalism, power addiction,
> fear, ignorance, arrogance, sabotage, stupidness and some-
> times walls of plain hatred — walls and walls and sheets
> and walls of it.[3]

If the conferences I discuss seek first to empower and
affirm their participants, it means that the constraints of polite-
ness and educating allies in the struggle are giving way to an
impatience with the very terms of current arrangements. As
Ahasiw Maskegon-Iskwew has said of his work as Canada
Council First Peoples Equity Coordination Intern, his goal
was to allow various communities — and not the Canada
Council — to define what constitutes an artist and art worthy
of funding.[4] As Allen concludes: "There are two significant
litmus tests for [the success of] anti-racism work: meaningful
change and critical mass."[5]

I will commence with a description of *In Visible Colours*,
organized in 1989 by Zainub Verjee and the National Film
Board's Lorraine Chan in Vancouver. This will be followed
by a discussion of the closed conference *About Face, About
Frame*. It was organized by President Premika Ratnam and an
ad hoc committee of artists of colour within the Independent
Film and Video Alliance/L'Alliance de la vidéo et du cinema
independents (IFVA/AVCI) in June 1992. The Alliance is com-
prised of approximately fifty independent film and video pro-
duction and resource centres across Canada.[6] The third event

(note 4 continued)
Buck' and 'Parallel Tracks' in the
Writers' Union's detailed final
report on the conference, *Writing
Thru Race Conference: Final
Report* (Toronto: Writers' Union
of Canada, 1995) available
through the Writers' Union of
Canada, Toronto.

5 Allen, "Transforming the Cul-
tural Fortress," 50.

6 In its bi-monthly *Bulletin*,
IFVA/AVCI describes itself as
incorporated in 1980, composed
of approximately fifty groups
engaged in the production, dis-
tribution, and exhibition of inde-
pendent film and video, and
representing over 7,000 individ-
uals. The primary objective is to
provide a national network link-
ing these groups and individuals.

is the formation of the Minquon Panchayat caucus within the Association of National Non-Profit Artists Centres/Le Regroupement d'artistes des centres alternatifs (ANNPAC/RACA) in 1992–93. Founded in 1976, ANNPAC was an association of approximately 100 artist-run centres across Canada. It was considerably re-structured in 1993, and briefly functioned as the Artist-Run Network.[7] The fourth event is a one-time conference that occurred in June 1994, *Writing Thru Race*, organized by the Conference Planning Committee of the Racial Minority Writers' Committee of the Writers' Union of Canada. The Planning Committee was made up of about fifteen Vancouver writers of colour and First Nations writers, most of whom were not members of the Writers' Union of Canada.[8]

Moving chronologically from 1989 to 1994, my descriptions summarize some different ways of addressing institutional racism. Language and procedure are pivotal points of conflict. I also explore how issues of race interact with the cultural mainstream. It is not coincidental that the impact of events gradually broadens: from the insulated impact of *In Visible Colours* and *About Face, About Frame* within IFVA and the independent film and video community; to the Minquon Panchayat caucus inadvertently prompting a radical restructuring of the seventeen-year-old organization, ANNPAC; and finally to hysteria in the mainstream media and a minor crisis in cultural funding policy within the Canadian House of Commons as a result of *Writing Thru Race*. In my view, this broadening demonstrates not only the extent to which issues of cultural equity are now inevitably impacting on the cultural mainstream in Canada, but also how repressed histories which have erupted in the Canadian social fabric are now coming to bear in the cultural domain.

In Visible Colours Film and Video Festival and Symposium

In November of 1989, Vancouver hosted *In Visible Colours*, a remarkable, groundbreaking international festival and sym-

7 For a brief overview of ANNPAC'S history and a focus on its attempts to deal with issues of gender, sexual orientation and most recently, cultural difference, see Lynne Fernie, "Editorial," *Parallélogramme* 19, no. 3 (Autumn 1993): 10–13. Fernie resigned as editor of *Parallélogramme*, published by ANNPAC, in solidarity with the Minquon Panchayat in the fall of 1993. She produced a final special issue entitled "Anti-Racism in the Arts" (Autumn 1993), based on the events that had transpired at ANNPAC'S Annual General Meeting. Since these events, *Parallélogramme* has published as *MIX*.

8 The Writers' Union of Canada is composed of 900 members and was founded in 1973. The Union's detailed final report on *Writing Thru Race*, is authored in part by members of the Conference Planning Committee, who also appended relevant media coverage on the conference.

posium showcasing the films and videos of women of colour and Third World women. In retrospect, it is useful to locate this unprecedented event within the proliferating context of a cultural production and theory that now finds race and race politics at its fore. Not unlike the impact feminist politics has had on the arena of culture over the last two decades, the effects of "the new cultural politics of difference," as Cornel West has effectively described it, is forcibly disrupting the traditional structures and paradigms of discourse and production. *In Visible Colours* made the explosive power of this disruption significantly apparent.

Seventy-five international delegates were in attendance, 100 film and videos were screened, and thirteen moderated panel discussions and workshops took place. The diversity of the opening panel hinted at the provocative exchanges of information and vast range of challenges that would be experienced over the break-neck, five-day schedule of events, as each of the five panelists voiced their equally significant but divergent areas of concern for their own practices and contexts of production. American film animation director Ayoka Chenzira underlined the importance of her alliance with black male filmmakers at a moment when "the police continue to enter our communities and murder our men and children" and concluded, "this cannot be denied in the name of a women's movement or feminism." Flora M'mbugu-Schelling described herself as the "only independent woman filmmaker in Tanzania," and expressed the hope of network-ing with women in Europe and North America, where easier access to materials, equipment, and films labs might facilitate the production and distribution of her films. Vancouver film and videomaker Loretta Todd spoke of the significance of these media as tools for telling stories, for voicing an affirmation of rights, and thereby aiding to create a measure of autonomy for Native cultures. Todd has also eloquently, if controversially, articulated the importance of Native cultural autonomy in her article, "Notes on Appropriation," where she argues that the current threat of cultural apartheid necessitates that Canadian

Native voices have sovereignty over their own images and
symbols in order to recover and write their histories. While
there is a known danger to this kind of separatism which femi-
nism has explored in great depth and alerted us to (in that
demarcations must be made between authentic and inauthen-
tic practices, determining who is allowed to speak on what
issues and determining how "certification" occurs, and by
whom), Todd's challenge is to recognize the specificity of
Native history and strategies needed to counter the potential
annihilation of Native cultures. In other words, Todd defines
the strategic necessity of developing a site-specific cultural
politic that may not only challenge, but also contradict other
models of cultural resistance.

Two contributions from Japan also elicited important
considerations of definition and address. Japan, not being a
Third World country, raises the question of how and by
whom women of colour are defined, clearly in relation to the
occidental West in this instance, and not specifically in relation
to their own cultural contexts. This further broached issues of
terminology and self-definition within an expanded identity
politic that now intersects gender with cultural and racial diff-
erence. Yet, in spite, or perhaps because of the complex chal-
lenges posed by the works screened and issues raised by the
symposium, there could be no denying the sense of empower-
ment attained by affirming such a complexity of identities
within the already marginal spaces that are women's film and
videomaking. Mexican videomaker Julia Barco's *Pregnant with
Dreams* (1988) embraced such contradictions and was in many
ways emblematic of the power of the utopic, transcultural
feminist politics (or *sisterhood*) that made *In Visible Colours*
possible; a politic that perseveres in spite of fracturing from
internal differences, and severe feminist criticism and demands
for specificity.

A diversity of Canadian works represented a cultural plu-
rality, and attempted to redress the absences of sexual and
racial difference within dominant, official histories. Films such
as Claire Prieto's and Roger McTair's *Home to Buxton* (1987),

Dionne Brand and Claire Prieto's *Older, Stronger, Wiser* (1989), and Sylvia Hamilton and Claire Prieto's *Black Mother, Black Daughter* (1989) all recover a remarkable but largely unknown history of Canada's Black communities through interviews and lively testimonials from older community members. Midi Onodera's *The Displaced View* (1988) more explicitly explores the reconstruction of histories by oral means, layering the lives and experiences of generations of Japanese Canadian women within her family. And Leila Sujir's video *India Hearts Beat* (1988) explores cultural displacement in a convergence of three women's movements through various actual and reprocessed Indian landscapes. Carol Geddes' celebratory *Doctor, Lawyer, Indian Chief* (1986) underlines the strength of Native heritage with its profiles of five Native women discussing their chosen careers. Loretta Todd's *Eagle Run* (1989) dramatizes the significance of oral culture and history for Native peoples, as a young athlete seeks guidance from her elders to learn the traditional meaning and spiritual importance of athletics. Many, many other films and videos deserve mention.

The works and discussions at *In Visible Colours* implicitly demonstrated the myriad insidious forms that sexist and racist ideologies will take and how they require a range of strategies and practices to be countered. Like sexism, the manifestations of racism are specific to social structures and contexts of power, and are further uniquely experienced by distinct racial and cultural groups as they are themselves intersected by gender, sexual orientation, and class differences. The profoundly felt subjective investments in these social and cultural explorations, as Loretta Todd's "Notes on Appropriation" eloquently reflects upon, further propel a constellation of conceptual contradictions as theory confronts practice.

As is no doubt evident here, it is difficult to speak of *In Visible Colours* in generalities. What emerged was a remarkable sense of difference within the sexual and racial differences that have marked women of colour working in industrialized nations, and women living and working in the Third World.

While the realization of this festival depended precisely on foregrounding the shared experiences of oppression, sexism, and racism lived by a global range of women, what the event and the screened works finally made apparent is how these realities are determined by specific social, economic, political, and cultural conditions. The availability of training and funding, access to materials and equipment, and structures of distribution are all determinations that are dependent on highly specific cultural and economic contexts of production.

I had opted to concentrate my time at the screenings, reflecting my certainty that the symposium would be recorded and documented, whereas many of the films and videos would not be guaranteed later distribution in Canada. In the final instance, the urgency of this distribution and visibility remains the central issue. What also emerged was the challenge of determining critical parameters for evaluation and discussion of these works and the range of issues addressed by them. The critical self-reflexivity induced by the vast range of factors begging consideration directly confronts common, so-called neutral technical, aesthetic, and political criterion for evaluation in a provocative way, as have the (now highly complex) critical positions prompted by two decades of feminist cultural production with its reverberations throughout the humanities and other fields of knowledge.

The closing plenary session of the festival further heightened the underlying difficulties facing future production and distribution as well as the corresponding need to ensure that this event would be repeated. Not unlike the closing session at the *Encuentra* in *Pregnant with Dreams*, where a Nicaraguan radical feminist suggests the possibility of smaller, separate *encuentras* to deal with more specific political needs (a suggestion made in light of the difficulties that vast differences and needs posed for practical problem-solving and strategy development), hundreds of women roared in disapproval, empowered as they were by the strength of the solidarity experienced quite in spite of contradiction and difference. Indeed, in celebration of contradiction and difference.

Midi Onodera
still from *The Displaced View*, 1988. Screened at *In Visible Colours*
Courtesy of the artist

Leila Sujir
still from *India Hearts Beat*, 1988. Screened at *In Visible Colours*
Courtesy of the artist

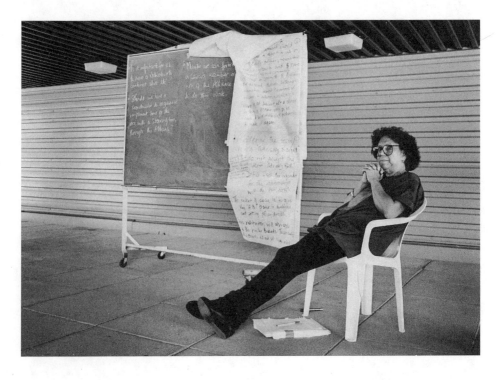

MONIKA KIN GAGNON

About Face, About Frame: Identifying Arenas of Discussion

About Face, About Frame was conceived as a closed conference of approximately forty participants from across the country involved in the production of independent film and video. Over the course of four days, participants made presentations of their work, and contributed to a series of facilitated workshops and sessions pertaining to the "distribution, funding, the negotiation of difference and the forging of solidarity, programming and exhibitions, employment equity and professional development, as well as a caucus on anti-racism strategies for artist-run centres."9 The broad aim of the sessions was to define working needs and to develop a strategy for providing support for First Nations artists and artists of colour.

Many of the sessions were particular to the concerns of film and video producers. On day three, facilitator Anne-Marie Stewart created a more general forum of analysis, which is interesting to consider as a point of departure here, for the way that it identified how subjective knowledge can be used to illuminate the operations of systemic racism. Stewart introduced three factors that interplay within institutions: the first is policy and proposed beliefs surrounding issues of racism; the second is individual experiences and behaviour with regard to policy and proposed beliefs about racism within an organization; and the third is the jobs, systems, and decision-making structures that arise around policy-making and the individuals functioning within them. She then proceeded to outline the historical development of anti-racist policy in organizations: from an archaic "no way" position, in which considerations of racial inequality in the workplace were nonexistent; to a "kindness of strangers" phenomenon, in which some acknowledgment of the impact of racial discrimination on work environments was possible, but addressed only because of the goodwill of random individuals; to the more recent affirmative action and employment equity strategies, which fundamentally recognize sexual and racial discrimination in the workplace, and designate programs to increase diversity, ideally countering the historical impact of inequity with proactive structural change.

9 Kwame Dawes, "Negotiating Difference: *About Face, About Frame* Coalition formed at Historic Banff Meeting," *Parallélogramme* 18, no. 2 (Autumn 1992): 12-14. For another descriptive review, see Mina Shum, "About Face, About Frame," *Fuse* 16, no. 1 (Fall 1992): 10–11.

It's a Cultural Thing
Youri Thomas performing at the cabaret
Calgary, 1993
Photo credit: Judy Cheung

About Face, About Frame,
Anne-Marie Stewart facilitating a session
Banff, 1992
Photo credit: Ali Kazimi

The fact that job creation programs frequently result in the perception of affirmative action as a hiring policy for individuals defined by their colour (or gender) over and above their skills was addressed. This often creates marginalized ghettos in the lower echelons of hierarchical institutions and a situation in which class and gender issues distort the realities of racism. In other words, the creation of "optics" means that people of colour are involved in institutions, but in menial positions that can do little to fundamentally challenge organizational structures. Thus a hiring policy based on skin colour means that affirmative action can be perceived as an internal threat to quality work and to existing and potential white employees.

Further, it was pointed out how frequently equity policy is formed without access to increased monies. The necessity to adhere to strict rules, guidelines, and categories of funding for such projects often results in the gradual absorption of anti-racist politics into the broader organizational structure. Competition for funding then effectively silences voices of opposition. As with affirmative action, target-group hiring is illusory and frequently creates backlash. In addition, training programs are often implemented without the possibility of actual jobs. Overall, equity policy seems to remain an "appendage" project unrelated to other systems within a given structure.

At an individual level, both types of policy — affirmative action and equity programs — result in experiences of tokenism, which frequently means scapegoating, being used as a pawn in political matters and, more personally, being the object of resentment. Individuals carry the burden of limited public definitions of who they are or what they are capable of without having any access to the power of actual decision-making regarding issues pertaining to race and racism (particularly if these entail structural change). This particular workshop effectively established a broad framework of analysis that evolved into a concrete strategy and resolution session later that afternoon, with the formulation of a document of recommendations for IFVA.

Minquon Panchayat: Cultural Equity Strategies Devised for Alternative Cultural Spaces

At the 1992 conference, "Contemporary Arts in Canada at the End of the Twentieth Century," organized by ANNPAC/RACA in New Brunswick, the keynote speaker, Lillian Allen (a dub poet and cultural activist), challenged the audience to acknowledge the dismally low number of people of colour and First Nations participants present. On a later panel (somewhat unfortunately, if revealingly, entitled "Anthropological Aspects of Contemporary Arts and Culture"), Allen invited First Nations individuals and people of colour to caucus. What would emerge from this seven-person group after several early morning and late night meetings was a caucus named Minquon Panchayat and a concrete document for the implementation of an anti-racism strategy specific to ANNPAC, entitled "Principles and Responsibility of the Advisory Committee for Anti-Racism."[10] The broad goal was to transform ANNPAC as an organization by bringing significant numbers of artists' groups and centres of colour and of First Nations into ANNPAC's membership; educating and transforming already existing member centres and their memberships; and networking those First Nations individuals and people of colour already working within the current ANNPAC centres.

The caucus "Principles" drew (if only implicitly) on a "Restructuring Proposal" drafted internally for the organization in 1991. As a participant in the fine-tuning of this "Restructuring Proposal," it was instructive to observe how the caucus' "Principles" initially depended on the space provided by the role of a proposed equity coordinator, but accelerated both the coordinator's pace and tasks. The proposal for an equity coordinator acknowledges the progressive intentions of ANNPAC and its membership. But more significantly, it also reveals the gulf between a predominantly white organization (albeit an alternative one) such as ANNPAC, and people of colour, their groups, and organizations who have a wealth of knowledge and experience from their work toward cultural equity. Notably, six of the seven members of

10 "Minquon" is a Maliseet word meaning rainbow, and is also present in other Native languages, while "Panchayat," originally Sanskrit, exists in various South Asian languages to refer to a traditional Hindu village "council of five" in which five elders governed. The Minquon Panchayat was conceived by Lillian Allen, Shirley Bear, Marrie Mumford, and Gloria Eshkibok, Zool Suleman and Sherazad Jamal of the Rungh Cultural Society, and myself. We were joined by David Woods, Paul Wong, and Dana Claxton, and later, by Cheryl L'Hirondelle, who became interim coordinator for the caucus and a main organizer of the 1993 conference *It's a Cultural Thing*.

the caucus were not officially affiliated with ANNPAC in any way. This suggests that an organization's attempts to deal with cultural inequity within its own frames of reference and without a radical examination of how it constitutes itself as an organization may be (despite ostensibly honourable intentions) completely ineffectual, or at worst, merely symbolic or tokenistic. Cosmetic modifiers, such as an equity coordinator, give the illusion that an organization is prepared to accommodate diversity. The danger is that it in fact simply remains trapped — ideologically, strategically, and practically — within the very structure that excluded people of colour from the cultural process to begin with. As I reread the "Restructuring Proposal" very early one morning in Moncton, a document I had already read a dozen times, I was struck by the fact that the terms racism and anti-racism were not uttered once throughout, despite being its *raison d'être*. I had merely assumed their presence before, without noting their absence. It was as if an organization that was willing to acknowledge the necessity of an equity coordinator was still unable to speak of racism.

Central to a consideration of the wide gap between a mainstream cultural organization and First Nations artists/artists of colour is the issue of "access," for access should be understood to be flowing both ways. It is only once the balance of cultural values and priorities shifts, and mainstream cultural organizations understand their potential enrichment, that meaningful change can occur. And these values and priorities fundamentally depend on definitions of power, knowledge, and language. The caucus was a spontaneous eruption within the structured parameters of a conference. Politically, that eruption had concrete effects in providing what Allen described as a vision and a road map for change over the ensuing year. For example, Shirley Bear, a Minquon Panchayat member, introduced a talking circle, transforming the usual modes of address and conduct at a conference in a simple but powerful and productive way.

The Minquon Panchayat was empowered to implement its principles by a modest budget allocated over the following

year. By the 1993 ANNPAC Annual General Meeting in Calgary, Minquon Panchayat had encouraged member centres to bring an artist of colour or First Nations artist as a conference delegate, and had organized a conference to precede the main event. The conference, *It's a Cultural Thing*, highlighted the work of forty artists of colour and First Nations artists in a three-day event attended by over 250 ANNPAC members and non-members.[11] During the ensuing meeting, however, events irreconcilably erupted with regard to the Minquon Panchayat's work over the previous year, through a form of resistance that can only be considered covertly racist. As I have described elsewhere, these conflicts were dominantly focused on procedural violations and alleged violations, which ultimately wore through the highly formalized process of the meeting.[12] When Minquon Panchayat reported on its activities, questions of how monies were spent were both unusual and inappropriate to the forum, particularly since all spending had been previously approved by ANNPAC's management committee. The introduction of new member centres was rapidly met with interrogations as to their qualifications as artists' groups — again unusual as new members are always nominated by existent members and this process had not been violated. Questions of legitimacy were perhaps prompted by the racializing context of the Minquon Panchayat.

Procedural language was thus used to reinforce the status quo of ANNPAC, enabling interrogations and exclusions in barely-veiled language of discrimination; violence masquerading as bureaucratic formality. As a consequence of increasing complications, the caucus departed from the meeting table. Many members subsequently resigned from the association. As I commented later, "Minquon Panchayat left the AGM table because what was clear to each of us was that it was not our responsibility to defend or justify our [volunteer] work."[13]

11 For an animated description of *It's a Cultural Thing*, see Cheryl L'Hirondelle's "It's a Cultural Thing," *Parallélogramme* 19, no. 3 (Autumn 1993): 28–35, and Ashok Mathur, "Troublemakers in training: notes towards anti-racist (art) activism and taking it to the streets. Calgary," in *Taking it to the Streets* (Toronto: SAVAC, 1998).

12 See my "How to Banish Fear: Letters from Calgary," in this volume.

13 Ibid.

Writing Thru Race: Creating Closed Spaces, Redefining the Terms of Negotiation[14]

Writing Thru Race: A Conference for First Nations Writers and Writers of Colour brought together 180 delegates from across the country for three days in Vancouver. Conference events included panel presentations, plenary discussions, round-table and caucus sessions, and workshops. The conference was sponsored by the Writers' Union of Canada, conceived by the Racial Minority Writers' Committee (RMWC) of the Writers' Union (formed in 1990), and organized by a working committee of Vancouver-based writers — including Chair Roy Miki, Larissa Lai, Joy Hall, Charmaine Parkins, Scott McFarlane, Anne Jew, Susan Crean, and Mark Nakada — who were predominantly writers of colour and First Nations writers.

Writing Thru Race can be seen as part of an ongoing process precipitated by challenges which have repeatedly brought issues of racism to the Writers' Union forum over the last decade. In 1983, Makeda Silvera's address to the *Women and Words* conference in Toronto foregrounded issues of race and racism in Canadian writing. In 1989, protests against the lack of representation of writers of colour and First Nations writers in the Writers' Union of Canada and in P.E.N. by groups such as Vision 21: Canadian Culture in the 21st Century, and Women Writers of Canada, took on a national profile in the media as a result of June Callwood's involvement; her reputation unfortunately became the focus of discussion and eclipsed any analysis of the systemic dimensions of racism which was the integral content of the challenges.[15] Then in May 1992, the RMWC organized "The Appropriate Voice," a gathering held in Orillia, Ontario, which brought seventy writers of colour and First Nations writers together for three days to identify common concerns and barriers to writing and publishing in Canada. *Writing Thru Race* emerged from this event as a recommended strategy.

Writing Thru Race's policy of restricting participation in workshops and panels to writers who identified themselves as

14 Sections of my discussions of *Writing Thru Race* draw on previously published material: "Landmarks and Landmines," *Front* 6, no. 1 (September/October 1994): 6–8, and "Writing Thru Race," co-written with Scott McFarlane in *Parallélogramme* 20, no. 2 (Autumn 1994).

15 See Scott McFarlane, "The Haunt of Race: Canada's Multiculturalism Act, the Politics of Incorporation, and *Writing Thru Race*," Fuse 18, no. 3 (Spring 1995): 18–31, for an extended theoretical exploration of *Writing Thru Race* and its emergence in relation to the Writers' Union. On the history of the Writers' Union and issues of racism, McFarlane refers to M. Nourbese Philip's *Frontiers: Essays and Writings on Racism and Culture* (Stratford, Ont.: Mercury Press, 1992), especially her chapter, "Disturbing the Peace." See also Roy Miki, "Sliding the Scale of Elision: 'Race' Constructs/Cultural Praxis," in *Broken Entries: Race Subjectivity, Writing*

First Nations writers and writers of colour was designed (according to the original call for participation) to "ensure a milieu in which writers directly affected by racism [could] engage in candid and personal discussions." *Writing Thru Race* effectively created this milieu in which writers, editors, theoreticians, and publishers networked and exchanged ideas. Implicit in the conference policy was the fact that participants themselves could establish the parameters of discussion without having to attend to the white guilt, anger, and defensiveness that have characterized and often dominated so many past discussions of race not only within the Writers' Union but in other cultural contexts in which race politics have come to the fore. Rather than a mixed forum in which a negotiation of politics, vocabulary, and strategy frequently dominate, the conference allowed instead for a focus on the production of bodies of work which, broadly defined, challenge traditional categories of writing and language, as well as conventional notions of history and culture.

Panel sessions were often held simultaneously (with up to four running concurrently), actually making it impossible to take in more than twenty-five per cent of the discussions. This tended to have the adverse effect of fragmenting any collective discussion or even experience of the conference. The shortcoming became evident during the scheduled caucus sessions and the two plenary sessions, and particularly affected attempts during the last day's plenary to focus on recommendations. While participants brought over seventy recommendations forward, it became unclear how and why the conference was identifying itself as a unified group in order to produce such recommendations. And also, to whom were these recommendations being directed — to ourselves as representatives of our own communities? to the Writers' Union? to cultural institutions, such as funding bodies or publishers?

In other words, the conference did not automatically produce a homogeneous politic with regards to self-identification, self-definition, or strategy. Contentions about "process" during the last hour of the plenary further accentuated the

(note 15 continued)
(Toronto: Mercury Press, 1998), especially pp. 144–152.

conference's "identity crisis," which had mostly gone un-
addressed during the conference itself. Particular motions
began coming forward, suggesting an adherence to voting
procedures and formal process that had neither been declared
nor agreed upon by conference participants. That the motions
were largely being made by Union members had the danger-
ous effect of directing and defining the conference in relation
to the Writers' Union, and could be perceived as an ideologi-
cal hijacking of the conference in the interests of a handful of
Writers' Union members.

In response to suggestions by some Union members that
there should be a massive influx of membership by conference
participants, Program Committee member Larissa Lai pointed
out that many *Writing Thru Race* participants were in fact
ineligible for membership without the publication of a "book
with a spine." She further remarked that the Union's definition
of what constituted a writer was restrictive and explicitly chal-
lenged by large amounts of work published in magazines and
chapbooks. Writer SKY Lee stated that she had no interest in
joining the Union despite her eligibility. Yet Union members
continued to espouse the virtues of the Union. A small group
of speakers on the floor attempted to challenge and interrupt
the implicit assumptions operating through the making and
passing of motions by Union members. But many more
conference participants had in fact already registered their
response to the direction of the plenary, because many had
left the forum out of disinterest or confusion.

Writing Thru Race is also notable for the level of main-
stream backlash that resulted from its participant policy. In the
months preceding the conference, there were repeated claims
made by Toronto *Globe and Mail* columnists Robert Fulford
and Michael Valpy that it was "racist against whites."[16] Then
in June, only weeks before the conference, Minister of Cana-
dian Heritage Michel Dupuy withdrew $22,500 of crucial
funding for the conference. Dupuy's announcement came in
the House of Commons after Reform MP Jan Brown's simplis-
tic accusations that the conference workshops were "racist and

16 Robert Fulford, "George Orwell, Call Your Office," *The Globe and Mail*, 30 March 1994, and Michael Valpy, "A nasty serving of cultural apartheid," *The Globe and Mail*, 8 April 1994. In response to her colleagues, Bronwen Drainie said "Females perhaps have more sympathy for the rationale behind the conference than do white males. For the past thirty years, considerable public funds have been spent in this country facilitating the coming together of women to help them plan strategies that would allow them to take their rightful place in a world dominated by men." Bronwen Drainie, "Controversial writers' meeting is both meet and right," *The Globe and Mail*, 16 April 1994. These articles and more are republished in *Writing Thru Race Conference: Final Report*.

discriminatory." Brown's comments completely denied the
intense effects of racism experienced by First Nations peoples
and people of colour. It also reaffirmed the current social and
political climate, which is increasingly hostile to cultural orga-
nizations defining themselves or their projects on the basis of
race, gender, and/or sexual orientation.

Dupuy's decision has been criticized as contrary to both
*multi*culturalism and the principles of affirmative action in the
Canadian Charter of Rights, and cryptically underlines the
Reform Party's ability to influence cultural policy in spite of
its reductive and uninformed critique. While an emergency
fundraising campaign within the cultural community and
trade unions was overwhelmingly successful in bridging the
budgetary shortfall and making the conference possible, the
double-edged implication of such private support is that it
alleviates the government's ideological responsibility to
proactively develop and support affirmative cultural policies.

The Power and Limits of Cultural Identity Politics

*The problem with race as special event is that like all specials
— lunch special, special of the day, flavour of the month —
they are, by definition, not the staple, not the norm. On the
other hand, without such events, the issue may never be raised
at all.*
— Richard Fung, "Conference Calls:
Race as Special Event"

*Without transforming core values around power and diversity,
the culture of domination will always frame the agenda and
shadow the relations between individuals.*
— Lillian Allen,
"Transforming the Cultural Fortress"

For the master's tools will never dismantle the master's house.
— Audre Lorde, "The master's tools will
never dismantle the master's house"

In Visible Colours, *About Face*, *About Frame*, the Minquon Panchayat, and *Writing Thru Race* forged collective spaces for many artists and writers who are Asian, Aboriginal, and Black. By creating a critical mass at an intersection with established cultural organizations, these events, in different ways, made the significant first step of facilitating increased access to the tools of cultural production, exhibition, and distribution. Integrationist strategies might further include redressing the exclusion of artists of colour in written histories, and countering the enduring misrepresentations that proliferate within the cultural mainstream. As the points of intersection proliferate, it has also become increasingly important to analyze how and why such absences and exclusions occur and become contained. In other words, how have racialized identifications impinged on practical strategies of cultural production? And how do alternative representations become, as Trinh T. Minh-ha puts it, "narrow, predictable representation"?[17]

17 Trinh T. Minh-ha, "The World as Foreign Land," in *When the Moon Waxes Red* (New York: Routledge, 1991), 192.

What is becoming increasingly evident, as forums such as these are provided for debate, is that to empower certain identities does not mean that they must merely be integrated into existing dominant Euro Canadian structures. One implication of these conferences is that it is possible to challenge ideological notions of what constitutes the Canadian public and the ways in which national funding bodies distribute funds. The events described overtly challenged notions of cultural universality. By applying for public cultural funding, the conferences insisted that the government recognize the politics of cultural difference functioning in Canada: that gatherings of First Nations artists/writers and artists/writers of colour are culturally productive spaces that should be valued by institutions. It also underlines how these institutions have historically functioned according to simplistic notions of multiculturalism, or else through cultural erasures which homogenize and define culture within Eurocentric traditions and criteria.

What the conferences also implicitly recognize to varying degrees is that bureaucracies and existing cultural organizations are not neutral sites, but themselves (even inadvertently)

perpetrators of racist practices. *In Visible Colours* and *About*
Face, About Frame created temporary collective spaces that
sought to strengthen its participants, to identify the needs of
its communities in a multilayered way, and in the case of the
latter, to bring recommendations back to IFVA. The Minquon
Panchayat operated as a caucus within ANNPAC, using its
resources to attempt a transformation of ANNPAC's administra-
tion and member centres. The *Writing Thru Race* Planning
Committee targeted resources toward an event that, initially,
had no overriding agenda in relation to its funding organiza-
tion, but rather was focused on creating a space of dialogue
for First Nations writers and writers of colour.

The concluding sessions of this latter event, however, pro-
foundly revealed the radically different ideological positions
that First Nations writers and writers of colour occupy in
relation to dominant culture and cultural organizations: from
assimilative to radically transformative. If all four conferences
implicitly challenged dominant notions of what constitutes a
Canadian citizen and valid cultural production, the procedural
wrangling of Minquon Panchayat with its "host" organization,
and of *Writing Thru Race* amongst its own delegates of colour,
foreground the various stakes and struggles now occurring at
the level of meaning and interpretation. Initial optimism for a
shared politic must give way to different, if more dramatically
effective, crises of representation. For as these events also
affirm, it is only when we might speak of the impact of self-
representation that the radical possibilities of cultural
transformation will have been truly explored.

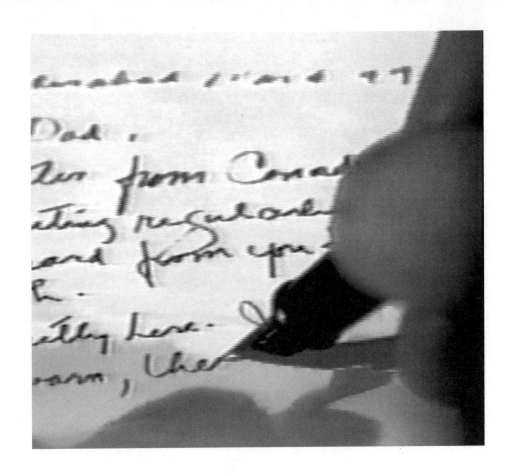

How to Banish Fear:
Letters from Calgary

October 2, 1993

Dear Jamelie,

Thanks for your letter and package. As always, your words
propel a galaxy of reflections for me, which are so welcome.
I'm looking forward to being in Québec with you for our joint
artist / writer residencies at La Chambre Blanche. I'm working
on the idea of delivering a letter to you when I arrive as my
contribution. In our last phone call you asked me about the
ANNPAC annual general meeting. It has been difficult thinking
through my involvement as a Minquon Panchayat member in
the last few weeks. I've begun "Letters from Calgary" for
Parallélogramme, which consists of a series of letters to differ-
ent individuals about the AGM events.

 While the intimacy of the letter format in our
collaboration allows me to traverse both subjective and theo-
retical terrains, it has risky implications in the more public
space of a published article. I feel much anger emerging
toward some individuals, and feel wary of how this creates a
counterproductive tendency to polarize the AGM participants
into monoliths of "us" and "them." In particular, I have to ask
would I send the letters I am writing? In effect, to publish
them is to send them. The challenge is to retain and mobilize
this personal anger, to effectively propel and situate it in its
social arena. The question is nothing less than what can be
spoken in the public sphere, what voice and language are

Leila Sujir
still from *India Hearts Beat*,
1988
Courtesy of the artist

acceptable. The vocabulary that addresses systemic exclusions — a polite lexicon of "access," "equity," "anti-racism work-shops," and "multiculturalism"— reveals on what terms white privilege most often allows itself to be challenged and trans-formed. Your brother Marwan's pointed words: "If you can-not speak through the great code, you cannot speak." How facetiously, irreverently, true!

I don't feel very anonymous right now. My own boun-daries between the political and the personal seem dissolved. I am trying to speak this dissolution, trying to map a shift and relation between these two spaces. I am ambivalent about introducing complexity into what is allegedly the "angry rhetoric" that charges racist practices, systemic exclusions, and white supremacy; complicating these concepts risks dilut-ing them to perilous abstraction. Yet these terms — racism, systemic exclusion, and white supremacy — are so useful in fundamentally insisting on the dimensions of power and its necessary shifting central to debates on systemic exclusion, at the same time as they need to be elaborated and dismantled. My further ambivalence is that explanations concede to domi-nant niceties, a "we are all human and need to talk to each other," which evacuates the public dimension. Too frequently, individual accountability for collusion with exclusionary struc-tures and practices disintegrates into confessions of guilt and absolution, as testimonies on interruptions into racist instances are defiantly uttered. As if such gestures solve the problem. These narratives have to be mobilized to public action.

I've become hyper-aware of my identity as a mixed person. I've recognized how Minquon Panchayat as a body within ANNPAC seems analogous to mixed identity, trying to attain some internal zone of compatibility and self-respect. Trying to create an active vocabulary on this subject risks essentializing hybrid identity simply by positing it as a bio-logical state of being. I am thinking more about exploring its social meaning, its implication for the meaning of "race"; something closer to the "third space" articulated by Homi Bhabha, an intersection of cultures from which something

different, unpredictable, and constantly changing might emerge. Mixed identity is in some ways to have that intersection socially and psychically written on the body. Cornel West wrote, "... the presence and predicaments of Black people are neither additions to nor defections from American life, but rather, *constitutive elements of that life*." Is mixedness that constitution?

Jamila's poem "ratio equality" is brilliant, republished in your *Jamelie/Jamila Project* bookwork:

young ban yen had been thought italian in kathmandu, filipina in Hong Kong, eurasian in kyoto, japanese in anchorage, dismal in london, england, hindu in edmonton, generic oriental in calgary, western canadian in ottawa, anglophone in montreal, métis in jasper, eskimo in the hudson's bay department store, vietnamese in chinatown, tibetan in vancouver, commie at the u.s. border.

on the whole very asian.

Jamila evokes the shifting perceptions that produce and impinge on identity, as each characterization speaks less of its "very asian" subject than of the social context of its utterance. I live this constant shifting: I am Vietnamese or Anglo in a Québecois context, French Canadian in an Anglo Québec one (or in France), *hakujin* in Japan, Japanese in China, Sicilian in St. Laurent. As a "political" artist, you have forged a respected space over the last eighteen years, working in a gradually transforming art world that doesn't feel the tectonic plates shifting underfoot, a movement that will happen with or without. You know otherwise, because your work has explored that zone which asserts the personal exigencies of living in a violent and racist world.

A friend invoked the crackdown on Black civil rights activists in the u.s. in the 1960s when I came home from Calgary and described, in so fragmented a way, the AGM events from my perspective. (I wish we were so grand, but

my paranoia was activated nonetheless, and I was grateful for the historical continuity.) She sensed tectonic plates shifting in the collective power I carried home with me in every cell of my body.

October 4, 1993

Dear Jamelie,

In response to your questions, I thought I'd share with you some sketchy notes about the ANNPAC events:

It's a Cultural Thing preceded the AGM, and was a remarkable two-day event of presentations by about forty artists of colour and First Nations artists.

Day 1: The caucus presents a twenty-minute report: I introduce and structure the different sections of the presentations; Marrie reads the original "Principles" presented and accepted at the Moncton AGM last year to historically situate Minquon Panchayat's work; Cheryl presents the details of our activities over the last year, summarizing reports published in *Parallélogramme*; Paul introduces the structure of the Minquon Panchayat Council to be put in place and made operative during the second year. There are questions from the floor throughout (I recall thinking about the nature of these questions and whether some are out of order to the formal reporting process).

A diagram of the Minquon Panchayat Council working structure for the coming year causes problems: where does ANNPAC fit in this diagram? But the highlight is when one regional representative intervenes in a heated and accusatory tone that the report is "unacceptable," and leaves the table. (There were later suggestions that this was not even a report because of the manner of presentation.) The Chair attempts to relegate further discussion to another time and forum as we are behind schedule, but more questions and criticism make their way to the floor before she finally breaks the meeting for

lunch. I spend lunch writing a statement with Marrie that retains the tone of last year's original "Principles," after someone suggests that a clear statement by Minquon Panchayat needs to come to the floor. Following lunch I read the statement, but no one takes it up and the meeting proceeds as per the agenda.

Nominations for elections: confusing and full of subtexts. Minquon Panchayat nominates a slate for the Executive positions, but again, there are later suggestions that this slate and its intent were not clear. Congratulations to Cheryl L'Hirondelle on what will be the shortest reign as president; she is voted in by acclamation.

A meeting between Minquon Panchayat and the Management Committee is scheduled for the evening. The caucus decides that Dana and Kent will facilitate a simultaneous information-sharing meeting and discussion for First Nations artists and artists of colour; this announcement causes much controversy. Objections to only the original caucus meeting with the Management Committee: why won't it be an open meeting? Some white delegates want access to the information meeting. And so on. Clearly a variety of people are feeling excluded at different levels. Discussion continues for ages. I don't stay, but both meetings seem cancelled.

Nonetheless: a large group ends up in Paul Wong's room in the evening. Shirley facilitates a discussion, and I arrive late with Lynne Fernie. There are about fifty people squished into the room, foot to back, piled closely on top of each other. People look tired, attentive, generous. There's a cross section of people here. It has been going on for hours and goes on for another couple of hours before turning into a party.

Day 2: The disintegration of hope for our work within ANNPAC continues during the acceptance of new members in the afternoon. The minute-taker introduces a divisive misinterpretation of bylaws that segregates the presentation of "new members" and "Minquon Panchayat members." Nancy Shaw intervenes, which brings about the presentation of all new

members together, but this distorted procedural ruse persists: there are seven dissensions to the membership of Absinthe, an artists/writers collective, predicated on the initial misapplication of the bylaws, a "violation of procedure," as well as some disciplinary question as to Absinthe's status as an artist-run centre. (On Edge, Desh Pardesh, and the Aboriginal Artists Group Inc. were also centres introduced to ANNPAC.) During the procedural recess following the first move to block Absinthe's membership, the misapplication of the bylaws is ascertained. The move to block is withdrawn, and all groups are accepted for membership.

The unfolding of the elections will be read by some as the reason for Minquon Panchayat's walkout. Minquon Panchayat's choice for Treasurer, Lianne Payne (Treasurer for the two preceding years), withdraws her candidacy in an emotional resignation and display that severely undermines Minquon Panchayat's integrity. Minquon Panchayat's choice for Vice-President, Sharon Fernandez, ties twice with two (in my view, extremely inferior) candidates, before withdrawing her own candidacy. (Sometimes a vote is not just a vote.)

There is so much that needs to be unpacked and addressed here. I know the narrative undercurrent, the accumulation and unrelenting wearing away of trust and goodwill. Some will refuse to see the events of the two days as having a continuum.

Another point of information: about two weeks following the AGM, ANNPAC responded to events by distributing a cover letter, summary of events, and questionnaire that attempted to interpret and manage the course and interpretation of the AGM. Michael McLennan, interim Managing Director, was instrumental in authoring this document.

October 10, 1993

Dear Jamelie,
The notes I last sent you were my attempt to sort out what happened in Calgary. Yet they did not assist me much in

finding an accurate explanation of why Minquon Panchayat was compelled to leave the AGM table. I'm sure you feel, as I do, a certain banality to this chronological elaboration that cannot even begin to describe my accumulation of reactions and en-suing analysis, nor those of every caucus member who sat at the table. But we did depart with full consensus.

The prism of various interpretations that followed the AGM emanates from profoundly subjective places that are frighteningly revealing. Everyone remembers different moments. Which moments are relevant to understanding? Who will claim what is relevant to an interpretation and analysis? What response will follow ANNPAC's retreat into a language of bureaucracy? The moment that resonates most strongly for me is the deafening silence at the meeting table when it was so essential that things be spoken. There seemed to be a profound risk in speaking to the issues raised, or those operating as sub-texts, and few dared to take that leap.

Laiwan's article, "It's a Cultural Clash," offers some accurate and pointed observations that characterize the AGM as "a highly formalized, uncreative, deadening process that made me realize that ANNPAC is a large, unfortunate group of people stuck in a process governed by a set of values that maintain this structure of Western Eurocentric power." I'm in complete agreement with this description. While I sometimes feel that the time it would take to analyze the various events is not worthwhile, there's also a part of me that wants to understand what, how, and why things happened as they did within this formalized process, to articulate the structure and politics of the language and ideology that was ushered in to control the interpretation and history of these events. For now, the anonymous language of bureaucracy has spoken most efficiently, if selectively and inaccurately. Understanding the consequences of this might provide some fruitful insights and politicize individual narratives rather than reaffirm polarized positions. For I view this event as nothing less than both political, in that Minquon Panchayat challenged the order and values of an organization that maintains white privilege, and also epistemological,

in that it has questioned ANNPAC's very terms of cultural self-determination and complicity in cultural domination.

Because certain individuals must, in my view, be held accountable, I am presented with the profound dilemma of how to name truths without positing essential accomplices and victims. What must be worked through, perhaps, is how individuals I know personally and professionally have actively contributed, in their actions or in their silence, to maintaining a much broader and pernicious racist structure. How can their participation be held accountable, be articulated in a way that might contextualize it as the very machinery of white privilege?

Paul said to me the other day, "No, no, no, we don't call it racism anymore, we call it what it is, white supremacy." Why can these terms now slide off my tongue, from my gut, with such ease? The operations of white supremacy are so clear, with regards to its maintenance of structures and procedures that protect white values and power. ANNPAC, once at the forefront of alternative cultural activity? How quickly those margins get redefined.

October 12, 1993

Dear Jamelie,
Our residency in Québec approaches and I am moving toward completing "Letters from Calgary." The structure of the correspondence — where various addresses are made to particular individuals — is creating such intimacy that it makes me feel uncomfortable and strategically disarmed. I am now writing all these letters to you because I am truer to my voice in the containment of this space where my words will not be judged as right or wrong, but as mine and valid.

What deeply fascinates me is how bureaucracy is the alienating and lifeless language of the status quo. The pretense to procedure contained in ANNPAC's "Summary of Events," I'll call the protection of privilege. I recognize so little in its interpretation of events. What dominates is a hollow attempt to

resist change and maintain "business as usual."

Puzzling to me is that, as anal about procedure as ANNPAC seems to have become, there is no date on the letter, no date on the appended document, nor any list of attendants at the cited Management Committee meeting where this unequivocal statement was drafted. In other words, no standard procedure is in evidence at all. It speaks nonetheless with a bureaucratic authority that establishes a summary of events that provides anonymity for those individuals who have taken it upon themselves to write one history, and protects them from accountability for this myopic, whitewashed version of events.

In this document, ANNPAC claims a willingness to work alongside Minquon Panchayat. However, there was never any communication to the caucus that a document was being disseminated from the office. This obvious contradiction speaks volumes. Such a paternalistic gesture claims goodwill, while harnessing the caucus into the terms of ANNPAC's control, defining events, staking the territory of interpretation, while denying the caucus an opportunity to have a complementary voice or position. Even the scientific language of physics has abandoned the possibility of objectivity, but ANNPAC implicitly makes that claim. Symbolically, the stake is that, with this "Summary," an irreconcilable split is described and confirmed rather than bridged, *perhaps for the first time irrevocably*. Ross Turnbull has a rather brilliant turn of phrase: "bureaucratic imperative," referring to institutional momentum for survival, despite meaning or relevance.

What the "Summary of Events" parrots is the mistrustful, insidious interrogation that permeated some (few), vocal AGM delegates with regards to Minquon Panchayat: that despite constantly monitored allocation of funds through the Executive, Management Committee, and Managing Directors of ANNPAC, Minquon Panchayat was somehow financially irresponsible; that despite representation by the caucus at every Management Committee meeting over the last year, and despite published updates in every issue of *Parallélogramme* and in ANNPAC newsletters over the last year, Minquon

Panchayat had somehow not provided information about its activities; that despite one year of ongoing work by Minquon Panchayat, an "impasse" had made this work so simply disposable. What the files will tell: that the initiatives of Minquon Panchayat were heralded by ANNPAC as its principal achievement of restructuring. ANNPAC: leadership role, at the forefront of anti-racism initiatives.

What is not evident is that each very, very busy Minquon Panchayat caucus member — Lillian Allen, Shirley Bear, Dana Claxton, Cheryl L'Hirondelle, Marrie Mumford, Paul Wong, David Woods, and myself — has given enormous volunteer time, ideas, consultation, and experience, as well as integrity, as individuals who solicited the trust and participation of many artists of colour and First Nations artists who would otherwise never have considered the artist-run network worthy of their energies or participation. Why an erasure of this valuable year? There is no recognition of any work done by Minquon Panchayat in the document, or any reference to *It's a Cultural Thing*, despite the fact that many regional reports at the AGM began by thanking the caucus for our work.

Minquon Panchayat is described as betrayed and disenfranchised; this makes us sound simply moody and temperamental. What happened is named as "hurt and frustration." I did not return to my home and job "shocked, dejected, and hurt," as is described (I incidentally don't have a job at the moment, as you know!). I went home relieved that I might never have to sit through an AGM again (this being my fifth, if most animated one, after 1991, when Québec centres left the conference table). The arrogance of presuming to speak for me or for the caucus is phenomenal. It is clearly a strategy of territorial domination, an attempt to reclaim power and control.

The "emotional" adjectives employed to describe the proceedings are telling, as they attempt to personalize all responses, evacuating the social and political dimensions of exclusion, and absolving individuals present of their personal, political responsibility; which is not to say there is not an

emotional dimension. Yes, it tears through the gut, which is largely because of its systemic dimension, the ways in which racism's reverberations, over and over again, contaminate all aspects of social life. This is why we need to create a dynamic between the personalization of events and its wider, systemic context.

I also refuse the assertion that Minquon Panchayat should take responsibility, as it has been charged, for miscommunication and lack of information and failure to circulate information about our activities. The centres themselves had a responsibility in their commitment to Minquon Panchayat one year ago, a responsibility to remain informed and relay that information to their own boards, staff, and memberships.

Minquon Panchayat said, "vision, movement, and networking initiative." It is as if some people understood this to mean Race Relations, and wondered when we might arrive with a travelling anti-racism sideshow, and a "certified anti-racist" rubber stamp for their foreheads. How devastatingly clear that our work was conditional on a liberal comfort or, dare I say, tolerance.

Lillian Allen offers a macrovision of change that liberates the imagination and suggests many possibilities for movement and transformation. Once you touch that vision, she said, you can't let it go, because it is so full of light and hope. Minquon Panchayat left the AGM table because what was clear to each of us was that it was not our responsibility to defend or justify our work. Minquon Panchayat punctured the seal that protects all the problems of ANNPAC's obsolete and bureaucratic system. The repeated trespassing into our autonomy (non-negotiable, as Lynne pointed out at the table), or alternatively, the voice of the delegates' silence, had led us all onto treacherous ground that had virtually eliminated Minquon Panchayat from the circuit of discussion: It became about ANNPAC's uncommunicative and flawed process; about a fear of changing or losing ANNPAC as it was constituted, as some clung desperately to procedure and outdated principles of self-definition. But no one would say it, though its dysfunction was so

apparent. This is why there came a point, which we each implicitly understood, when we would no longer speak and this is why it became untenable to remain at that table.

November 14, 1993

Dear Jamelie,

Our joint residencies in Québec now seem like some haven that could be a figment of my imagination. The marble hyphen cube that you gave me as a memento of your installation sits now conspicuously on my shelf. It elicits fragments of the many conversations we had during our nine days together. How perfectly heavenly to have spent this time working and talking and thinking with you. It was significant for me that you read my "Letters from Calgary," and that the unfolding of details about the AGM was merely secondary to your immediate dismissal of currently circulating information, commentary, and gossip: that you trusted and respected every person on Minquon Panchayat, period.

I have also been thinking about your conversations with your son Tariq and his disillusionment with university. As we discussed, it really indicates a growing disjunction between the social structures we are all forced to negotiate as citizens and what we want from our lives. If we are from generations that actively and hopefully interface our politics with the structures within which we live and work, Tariq is representative of a politicized generation behind us that is finding the effort of transformation increasingly difficult.

The histories, interpretations, and knowledge perpetuated through so-called higher institutions of learning, and through our cultural organizations, have become transparent in their ideologies. They are false, and Tariq knows more and better because your life has taught him this. The task at hand is nothing less than to imagine and invent, trust a voice and process to change this. I optimistically believe in the possibility of transforming some of the contents within which we live.

I understand the integrity of disillusionment, the ambivalence that underpins all efforts to operate at this intersection. But what more is there than to write and rethink the world?

Lillian said to me last night that if Malcolm X and Martin Luther King had ever publicly spoken together, their suspensions of difference to speak in solidarity might have meant that America today would be profoundly different. But they never did. She also said I have to banish fear and guilt from my vocabulary.

Bye for now,
Monika

Primer for Xenophilic Beginners

Access: As a concept, access acknowledges that most organizations are exclusive and closed to particular Others and seeks participation and individuals from Other groups. In practice, access should fundamentally encompass support of self-determination, though it most often doesn't. In other words, cultural equity's not just about choosing some token figureheads to represent Others, but is a challenge to think through all the reasons access is even being considered, and transform accordingly and completely, step by step.

Anglo-conformity: Politely speaking, this really means a Canadian ideology of white supremacy. Will undoubtedly be increasingly used as *multiculturalism* (see below) is more rigourously debated.

Anti-racism: One effective anti-racism facilitator is dissatisfied with this term because it operates in much the same way as anti-perspirant, merely as a blocking device.

Anti-racism workshop: Largely a costly delaying tactic to avoid implementing steps to *access* (see above) and structural change in institutions suffering from *systemic racism* (see below), workshops operate mostly as "sensitization" sessions. Allowing participants to learn and try out new terms (such as those in this glossary). Also a generous environment where you can debate and discuss with peers whether racism actually exists or not, and test out the boundaries of what's socially acceptable and not.

Cross-cultural: One step up from *race relations* (see below), this term is strangely evocative of a "contact" mentality, which posits segregated cultural communities as unmoving, static entities requiring government programs to bring them alive.

Internalized racism: I wish I didn't keep having to learn about this one.

Multiculturalism: Canadian policy supporting cultural diversity, passed as an official act in 1988. So Canada's got culture and multiculture.

Political correctness: Scary, this one, largely an invention of the Right in its current usage, the term attempts to discredit, dismiss, and silence, in blanket fashion, criticism of and challenges to status quo racist-sexist-homophobic language and social life.

Post-colonial: Deeply offensive to First Peoples.

Race Relations: Offensive, don't even try to understand this one.

Racism: Seems to send some into spasms when accused of it, this might be more usefully understood as manifesting itself in social practices, including language, and therefore, is a changeable, rather than an incurable, state of being.

Systemic racism: Look around your workplace and what do you see?

White privilege: Think through the privilege you have.

MONIKA KIN GAGNON

White supremacy: Defined in several dictionaries as an Americanism, this term should be situated in its specific political implementation and practices (i.e., South Africa and scary pockets of the U.S.), as well as, more accurately, a general condition of oppression. Though white supremacy describes an obvious social state of affairs, it invokes issues of power, violence, and domination into the sometimes less effective descriptive *racism* which, in turn, elicits spluttering spasms (see *racism* above), or charges of *political correctness* (see also above).

Xenophilia: One of those chameleon terms that seems to shift meaning depending on why it is spoken. Recently coined to counter ever-present xenophobia — generally speaking, an unreasonable fear of Others — xenophilia seeks celebration of these same Others, and, I assume, self-love. I need to think above this one more.

How to Search for
Signs of Asian Life
in the Video World[1]

Histories are unruly things. Some squirm to avoid the very meanings they feel they've learned from experience, and the dominating histories that have been constructed to lay their bloated smothering forms on top of smaller, quieter histories.
— Richard Hill, "One Part per Million, White Appropriation and Native Voices"

Cultural difference is not a totemic object. It does not always announce itself to the onlooker; sometimes it stands out con-spicuously, most of the time it tends to escape the commodify-ing eye. Its visibility depends on how much one is willing to inquire into the anomalous character of the familiar, and how engaged one remains to the politics of the continuous doubling, reversing, and displacing in marginality as well as to the necessity of changing oneself-as-other and other-as-oneself.
— Trinh T. Minh-ha, "Bold Omissions and Minute Depictions"

Making Noise in the Silences of History

It is commonplace to address the fictional and subjective nature of history, even in art history. In 1976, A.A. Bronson wrote in "Pablum for the Pablum Eaters," "History is never made — it is written."[2] Griselda Pollock's interventions as a

1 Some clarification of terminology with regards to "Asian Canadian": I concur with Richard Fung's discussions of the different specificities—East, Southeast and South Asian—that have come under the descriptor "Asian." My text refers to East Asian Canadian which in places I use inter-changeably with Asian Canadian. See Richard Fung, "Seeing Yellow: Asian Identities in Film and Video," in *The State of Asian America: Activism and Resistance in the 1990s*, ed. Karin Aguilar-San Juan (Boston: South End Press, 1994).

2 A.A. Bronson, "Pablum for the Pablum Eaters," in *Video by Artists*, ed. Peggy Gale (Toronto: Art Metropole, 1976), 196.

opposite page
Ken Kuramoto
still of Roy Kiyooka
from *The Blue Mule Interviews*, 1985
Courtesy of Video Out

feminist art historian engaged the political meaning of art history with such imperatives as this:

> What we need to deal with is the interplay of multiple histories — of the codes of art, of ideologies of the art world, of institutions of art, of forms of production, of social classes, of the family, of forms of sexual domination whose mutual determinations and independence have to be mapped together in precise and heterogeneous configurations.3

No small challenge for feminist art historians. I would highlight my own tortured two pages of qualification about the subjective process of historical selection in my essay "Work in Progress: Canadian Women in the Visual Arts 1975–1985." The ways in which a historical fiction is written is contingent on the demands of one's subject matter and the questions that one poses while compiling and sifting and then privileging information. But it can also be dangerously contingent on the answers one wants as result. A.A. Bronson also added quite cynically in this regard, "More recently, and particularly in art circles, history has become a means of anticipating the future in order to plan one's own work as the next logical step in art history. In other words, history has become a *marketing device*."4

Video art is a chameleon form to contend with. In its practical usage, it has been used to document performance in an emphasis on video's most basic function over any formal concerns. Video as a new technology has been explored by artists working in other media in a manner that characterizes the early history of experimental film. An experimental, formalist emphasis has been subverted to emphasize video's potential in effectively conveying information, developing the medium's potential as an oppositional practice capable of intervening in the hegemony of mass communications. And these broad categorizations contain many more.

Examining the documentation of major Canadian video conferences, such as Matrix in 1973 or the Fifth Network

3 Griselda Pollock, *Vision and Difference: Femininity, Feminism and the Histories of Art* (New York: Routledge, 1988), 30.

4 Bronson, 196.

5 See Sara Diamond, "Daring Documents: The Practical Aesthetics of Early Vancouver Video," in *Vancouver Anthology: The Institutional Politics of Art,* ed. Stan Douglas (Vancouver: Talonbooks, 1991), 56–57, for a discussion of Matrix Conference in 1973. For an example of the different concerns facing video artists in 1978, see, for instance, Andrée Duchaine, "Fifth Network, Cinquième Réseau," reporting on the Fifth Network, followed by regional takes on the conference by Lisa Steele, René Blouin, Terry McGlade, Pierre Falardeau, Brian McNevin, and Claude Gilbert, *Parachute* 13 (Winter/Hiver 1978). A seminar workbook from the conference was published and is available through Art Metropole, reviewed by Clive Robertson in *Centrefold* 2, no. 6 (Sept. 1978).

Conference in 1978, illustrates the variety of issues that have

faced video since its early use.5 What is consistently striking is
that from the late 1960s, the development of video in Canada
is attended by an almost obsessive quest for self-definition.6
Practically speaking, broadcast television and film (with their
similar physical and technical properties) were impinging
presences video could literally not afford to ignore. The exer-
cise of legitimation, though often characterized by debate and
disagreement about video's nature and its usage, was a signifi-
cant process in the forging of a space that cultivated access to a
financial economy within the cultural funding apparatuses,
whose categories of eligible media did not yet accommodate
video as a new and initially experimental, cultural technology.

The emergence of artist-run centres (ARCS) — as a parallel
structure of production, exhibition, and distribution of cultural
practices throughout the 1970s — developed as an alternative
to the hegemony of commercial galleries and mainstream pub-
lic institutions, challenging their powerful ability to determine
and effectively reproduce aesthetic notions of high art import-
ed from Europe and the U.S. Performance, installation, and
video were merely nascent forms, as of yet unacknowledged
and dismissed by mainstream art and its institutions. That these
forms defied the commodification and salability of art was
their precise point, inevitably resulting in their initial exclu-
sion from exhibition in commercial, market-driven venues.
It was predominantly through the arcs that these new media
were able to flourish. Tracing video's development in its vari-
ous forms and its various sites of reception situates Canadian
video practices within a number of parallel structures: parallel
to other established art forms, parallel to mass culture, and in
many ways, parallel to official culture in its venues of
exhibition.

In defining its identity, numerous histories were written
characterizing the simultaneous but different developments
of video in the Canadian quadrant of Vancouver, Toronto,
Montréal, and Halifax.7 This occurred even more extensively
as video production facilities increased, exhibition venues

6 As the title of Renee Baert's
"Video in Canada: In Search of
Authority," suggests in *Vidéo*, ed.
René Payant (Montréal: Artextes,
1986), 42–55.

7 See for instance, Peggy Gale,
"Video Art in Canada: Four
Worlds," *Studio International*
(May/June 1976).

expanded, and the gradual entry of video into mainstream public art institutions meant larger audiences that required initiation into viewing and introduction into the meanings produced by this blossoming new technological form. One consequence of the continual (re)discovery of video and restating of video's history, as Lisa Steele has remarked, was that "video was continually returned to its birth, maintained in a constant state of infancy."[8]

Martha Rosler, in her essay "Video: Shedding the Utopian Moment," concludes that "video's past is the ground not so much of history as of myth."[9] Rosler's analysis is particular to American video but is useful to a Canadian analysis insofar as it defines the dubious potential of separate art and social trajectories for video history. Rosler underlines the possible trajectories of a video history, to be written, through a logic that considers the existing "myths" that ground video history, suggesting, in virtual resignation, that "Video history is not to be a *social* history but an *art* history, one related to, but separate from, that of the other forms of art. Video, in addition, wants to be a major, not a minor art."[10] She adds, in a more particular but similar sentiment to A.A. Bronson's statement, that "Video histories are not now produced by or for scholars but for potential funders, for the museum-going public, and for others professionally involved in the field, as well as for the basis for collections and shows."[11]

Rosler proceeds to isolate "the figure" of Nam June Paik and traces how his presence in video's mythic histories combines "the now familiar antinomies, magic, and science that help reinforce and perpetuate rather than effectively challenge the dominant social discourse."[12] Nam June Paik, Korean-born, brought up in Tokyo, an avant-garde musician and composer with a university degree in aesthetics (thesis: Arnold Schoenberg) and student of German modernist composer Karlheinz Stockhausen, becomes firmly entrenched as the grandfather of video. And attributed to him is the importation to New York in 1965 of the first ½-inch video Sony Portapak. Rosler writes:

8 In conversation with Lisa Steele, April 1992.

9 Martha Rosler, "Video: Shedding the Utopian Moment," in *Illuminating Video,* eds. Doug Hall and Sally Jo Fifer (New York: Aperture and Bay Area Video Coalition, 1990), 42.

10 Ibid., 42–43.

11 Ibid., 44.

12 Ibid., 46.

The elements of the myth thus include an Eastern visitor from a country ravaged by war (our war) who was inoculated by the leading U.S. avant-garde master while in technology heaven (Germany), who, once in the States repeatedly violated the central shrine, TV, and then goes to face the representative of God on earth [the Pope], capturing his image to bring to the avant-garde.... And — oh yes! — he is a man. The hero stands up for masculine mastery and bows to patriarchy, if only in representation. The thread of his work includes the fetishization of a female body as an instrument that plays itself, and the complementary thread of homage to other famous male artist-magicians or seers (quintessentially, Cage).[13]

13 Ibid., 45.

14 Ibid., 46.

Rosler undertakes a persuasive analysis of the nature of the avant-garde and its historical relationship to mainstream culture. She situates and stresses Nam June Paik's cultural origins and his mythic presence as grandfather of video. She elaborates Paik's affiliations with musician and composer John Cage, and further underlines Cage's interest in Eastern-derived mysticism, "the antirational, anti-causative Zen Buddhism, which relied on sudden epiphany to provide instantaneous transcendence..."[14] But the analytical potential I waited for from Rosler was not to manifest itself. One which might have understood the "shock tactics" of the avant-garde work of Cage and of Paik, their impact on Western high art, in terms of the derivations from Oriental philosophies, conceptually and symbolically situated as the complete other of Western culture.

John Cage remains a mentor to Paik in Rosler's text, but in some ways he could be seen as essentially legitimizing Paik's presence by operating as Paik's cipher into the Western avant-garde world. This begs undertaking a more in-depth consideration of Paik's presence as an Asian male (as Rosler high- lights) that both entices and threatens. While a relationship between East and West that I am hinting at is admittedly far more complex than my expectations in Rosler's text might

suggest, my own orientation in research had me reading with bated breath to elaborate the cultural meaning of video's literal importation and video's sustenance as an avant-garde practice by and through a figure such as Paik. But I was left wondering, instead, how Paik's configuration within a complex legacy of orientalism could, firstly, be left unarticulated more explicitly (characterized by Rosler merely as "science and magic"). And also left pondering the more provocative implications of how Paik might be situated in an alternate (social/ art) history that might engage his Asian identity in a framework of identity politics. To offer Paik, in other words, historical access to a discursive project that encountered and engaged race and racialization in a direct way.

In "Daring Documents: The Practical Aesthetics of Early Vancouver Video," Sara Diamond clearly distinguishes a more specific arena of investigation than Rosler's expansive one, that of documentary video production in Vancouver. Though dealing with different contexts of video production, it is interesting to consider Diamond's essay alongside Rosler's as methodologically exemplary, feminist critical histories, projects with which we could consider a relationship of coalition with a cultural politics of race.

Diamond explores Vancouver's "identifiable subculture within the West Coast artistic community," in which "early tapes subordinated the formalist emphasis in the aesthetic dimension of video to the medium's use value...."[15] She situates a specific history of video production whose cultural contribution is maintained as one of social affect, therein mapping a social history as an aesthetic subculture, and therefore as one contained *within* an aesthetic discourse.

Reference to Paul Wong's work, in particular, the cancellation of his exhibition *Confused: Sexual Views* at the Vancouver Art Gallery (VAG) in 1984, frames Diamond's analysis of definitions of "art" and "not-art" as it pertains to video.[16] But this would, like his work throughout the 1970s and early 1980s which dealt predominantly with issues of representation and glamour, give no explicit evidence of a racially conscious

15 Diamond, 47. A sub-title of Diamond's essay is "Martha Rosler's Utopian Moment."

16 Ibid., 47.

Richard Fung
still from *Fighting Chance*,
1990
Courtesy of V Tape

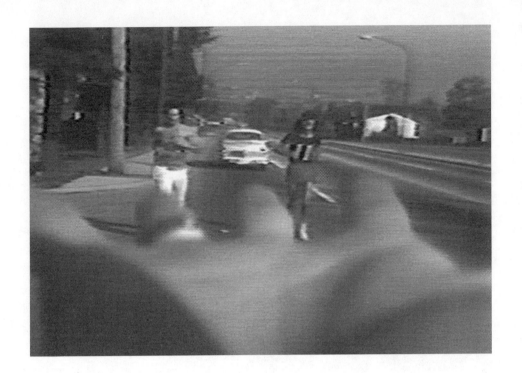

self-positioning, other than the signifier of his Chinese sur-
name, or his appearance in videos and stills which made
apparent his particular racial background.

Later in her essay, Diamond writes that "Perhaps the most
significant *new* developments in film and video have come in
community productions by aboriginal artists and artists of
colour."[17] Notable is that this observation is made only once
producers and their self-determination with the tools of video
production, have forcefully made their appearance on the
video stage in their own voice, and further, that the content
of these artists' work reflects their overt political identification.
Diamond cites Loretta Todd, a Cree video-maker and writer
who according to her:

> ...traces the role of the white cultural missionaries who
> introduced video to native communities, believing that
> natives would choose to join the global village, ignoring
> the traditional forms of preservation that native communi-
> ties had maintained. Todd decries the ongoing colonizing
> practices of white video producers who have built their
> careers on the exotica of native culture and history.[18]

Diamond affirms the production of work by artists of
colour and First Nations artists, and acknowledges a discourse
which is engaged with issues of race. However, she only cau-
tiously gives voice to cultural difference within a designated
space of discussion, rather than allowing herself to discover
its tropes as intrinsic to the very history she writes. Thus the
absence or invisibility of working artists of colour, or Native
artists throughout the 1970s and 1980s history which Diamond
writes, remains explicitly unaddressed. This allows individuals
such as Paul Wong and Taki Bluesinger to partake in the more
general history of which they are part without in any way
being identified as "different" or distinct from the rest of the
(seemingly) white pack.

While heeding to Todd's position in describing the outrage
of appropriation and patronizing of Native cultures — note

17 Ibid., 76 (emphasis added).

18 Ibid., 77.

Taki Bluesinger (with Paul
Wong and Gerry Gilbert)
still from *New Era Marathon,*
1973
Courtesy of Video Out

that "*Todd* decries," not Diamond — she remains curiously selective in her representation of Michael Goldberg whom she describes as "a paternal figure at the [Video] Inn." Goldberg emerged again and again in my own research through magazine and catalogue archives as a significant facilitator and supporter of Japanese video artists and exchange events, and was also notable for his production of videos exploring Japanese culture. Yet in Diamond's essay, he is mentioned only for his video, *Orgasm,* with a hilarious quotation from an awkward sequence on female orgasm between himself and an uncomfortable female subject, Elke Hayden. His curatorial work and his own videos engaging Japanese culture remain curiously absent. For Diamond to articulate Goldberg's work around Japanese culture might have begged an elaboration she was unwilling to undertake since it reeks of the very sticky quagmire of orientalism that is a virtual Pandora's Box. The issue of the cultural representation of other cultures is referred to only as it pertains to the specificity of Native cultures, and further, with a caution whose articulation is that of a Cree woman, Loretta Todd.

My subtextual readings should not deter from the fact that both Rosler's and Diamond's essays are insightful. My reasons for citing them together have an ulterior motive, however: to draw out what I sense remains unspoken within them. For I would suggest that both articles demonstrate a political *politesse,* a restraint which stops them from making explicit the subtexts of racial and cultural difference within the histories they map. This observation is not to suggest that either writer is obliged to speak overtly to such concerns. It is, rather, to explore the ways in which cultural difference and race erupt only as repressed lacunae in works whose political logic and social analyses (fundamentally and significantly grounded in a feminist politic) would seem to lead toward certain other strategic coalitions and critiques. In other words, despite being informed by feminist sensibilities, the arena of cultural difference appears to pose certain (unexplored) difficulties. What we can garner from Diamond's cautious political strategy is the

importance for oppressed and marginalized voices to speak, organize themselves, and claim their own subjecthood. For even in well-meaning contexts, such spaces may not be forged at all.

A number of questions arise: How and why are certain voices "allowed" to be heard at particular moments? Why race now? And under what conditions will its exigencies be accommodated? What role and effect does the overt politicization of identity (or consequently, the lack thereof), have on the ways we reflect on and even write cultural histories? How does it affect what artists and works will even be disseminated?

I will suspend these questions to assert a far more simple observation. Namely, that what becomes evident in examining the body of writing on culture in Canada are the radically shifting terms of discourse around issues of race and cultural politics of difference. This is significant. For what might be understood to be haunting Diamond's and Rosler's texts (and this haunting is both productive and revealing), are the consequences of the absence of a vocabulary for white feminists, to speak critically to the operations of race, racism, and cultural difference. And further to comment on a cultural production that engages these very issues. The absence of this cultural vocabulary hinges on a much larger historical silence.

19 Paul Wong, "Introduction," in *Yellow Peril: Reconsidered* (Vancouver: On Edge, 1990), 2.

Some Signs of Early Life

"I have defined 'Asian' by the colour of our skin and the geographic region it implies," wrote Paul Wong in his catalogue introduction for the group exhibition *Yellow Peril: Reconsidered*.[19] Wong's definition recalls how I began my research, by simply asserting a category, East Asian Canadian video production. But was this category merely self-explanatory? What was I looking for? Asian-sounding names? Asian-looking faces? All in spite of the content of artists' work? Any-thing with Asian content? Or work exclusively on identity and culture by Asian-seeming artists?

In wanting to contextualize these video practices in a wider history, the dangerous essentialism of this categorization became increasingly apparent, and its limitation for any historical project, also evident. Videos by East Asian Canadian artists prior to 1985 could in no way be predominantly characterized by any overt references to Asian identity or culture. In other words, traces of "Asian-ness" are detectable only in the heritage/biology of the authors, whether by appearance or by name. Since 1985, however, I would observe that videos by Asian Canadian artists such as Richard Fung or Ruby Truly, as well as by artists such as Paul Wong and Fumiko Kiyooka, who were producing works prior to 1985, are dominantly characterized by politicized identifications, and also, by explorations of East Asian culture and Asian-ness. Representations of East Asian identity existed during this pre-1985 period, but were most often undertaken by white video artists. Susan Britton's *Me$$age to China* (1979) serves as one extreme example wherein, among other scenes, there are shots of "Teng-Hsiao-Ping looking mildly disgusted while a punk band [is] tuning up...," and another, which caricatures Chinese women in a manner virtually unthinkable today, in which Britton is "made-up traditional Chinese-like, toying with a fan, and a sound track of her voice stumble[s] through a contemporary Chinese political slogan."[20]

20 Karl Beveridge, "Colonialist Chic or Radical Cheek?" *Centrefold* 14 (June/July 1979): 271.

The parameters of my criterion were becoming increasingly tenuous and the constructedness of this East Asian category, and consequently of my own project, more evident. Inclusion based on the heritage of the producer was, in some instances, to politicize a context and identification which did not themselves articulate racialization. While not problematic in itself (in fact, precisely what I was pondering doing to Nam June Paik), a consequence of projecting a racialized reading might be to overlook examining the social character of the absence of self-conscious racializing. In my desire to politicize a context, then, I might not examine the specificity of this context where a politicization of identity did not occur, also where a cultural analysis of race, and of racism, were not socially

accessible discourses. On the other hand, to focus selection based solely on a producers' East Asian self-identification and cultural reflection as context, would impose a structure of value that validated certain practices as authentically East Asian despite the highly relative and artificial state of such cultural categorizing.

The politically explosive potential of my seemingly straightforward project had asserted itself. In even suggesting post-1985 video production as "dominantly characterized by politicized identifications and also, by exploration of East Asian and East Asian Canadian culture and Asian-ness," as I did above, I would have to consider the current demands of curatorial projects and distribution apparatuses that perhaps necessitated politicized works to be disseminated over and above non-politicized ones. In other words, the distinct articulation of differences would be understood as a conditional requirement for containment within and entry into a broader, white-dominated cultural context.

Politically racialized representations expand the project of earlier identity politics in cultural practice defined by feminisms, gay/lesbian or class identifications. While the exploration of masculinity by straight male artists might be considered as a relatively recent development, these gendered or racialized subjectivities are distinct for the individualized, narcissistic exploration of the self, a temptation in video, perhaps, because of the technology's accessibility and mobility. In fact, the articulation of politicized identifications as engaged in "public" relations of power, strongly counterpoints the highly "privatized" space of the individual and its confluence with a universal "I" straight, male, and white.

Politicizing an identification which has created oppression — in this case, celebrating "colour," that visual signifier of difference which results in racist experiences within white-dominated culture — is to simultaneously distinguish that difference, but within a framework which may continue to respect the terms which have allowed for patriarchal and racist ideologies to predominate. Colour, in other words, only needs

definition in relation to an ideology of racism that privileges whiteness. As Richard Fung writes,

> Given that the form of racism we encounter in North America is that of white superiority, it isn't surprising that the struggle for Asians to reclaim our subjecthood (or to shed otherness) has been phrased as a tug of war between white and yellow. But something is wrong with this binary opposition of white oppressor and yellow oppressed. Whereas racism privileges whiteness and targets a somewhat shifting body of "others," anyone, no matter of their status or colour, can engage its discourses.[21]

While there are risks in homogenizing "people of colour" in the demand for overt significations of difference, there are also risks involved in forging *any* differences within the already precarious space of difference in mainstream culture; that is, in appearing fragmentary and inconsistent on already precarious terrain. Richard Fung has written, almost apologetically, with regards to his videotape *Fighting Chance* (1990):

> The tape does not directly address the issues of Asian PWHIVs, who are isolated, confused, illegal, closeted, or those who don't speak English. Yet, because all the men in the tape are Asian, they can be seen to speak for all Asian PWHIV's. And with the standard practice of tokenism at the level of funding a whole range of concerns may never be addressed because there is already one video on gay Asian men with HIV.[22]

What Fung's comments suggest is what Kobena Mercer has described as the "burden of representation."[23] That is, as artists or writers addressing issues of difference, the responsibility and expectation to "get it right," or to "say it all," because this may be the only definitive opportunity to speak, is both enormous and overwhelming. As Fung also confesses, "Whenever I detect this expectation — and it is often —

21 Fung, "Seeing Yellow," 164.

22 Richard Fung, "The Trouble with 'Asians,'" in *Negotiating Lesbian and Gay Subjects*, eds. Monika Dorenkamp and Richard Henke (New York: Routledge, 1995), 126.

23 Kobena Mercer, "Black Art and the Burden of Representation," *Third Text* 10 (Spring 1990): 63–78. Mercer writes: "Because our access to [institutional] spaces is limited, each event has to carry the burden of being representative; and in this way, because there is no continuity of context, we seem to be constantly re-inventing the wheel when it comes to criticism," 63.

I feel like an imposter."[24] Which might lead us to ask what it is about the current state of discourses on cultural and racial difference (in 1994) that has made the stakes of speaking so complex. The imperative to speak to one's visible difference and be "representative" is, in some ways, to adhere to a structural logic of marginality.

To politicize an oppressed identity is to representationally shift from a subjective place of invisibility or inferiority to one claiming powerful identification. The imperative to remain within a marginalized, oppositional, but distinctly identifiable subculture understandably responds to the oppressive domination of white cultures. To move beyond a celebratory accommodation toward a structural analysis that identifies the multiple ways in which such domination persists is the significant next step. And this may involve recognizing the extent to which political positioning within celebratory, marginalized economies may inhibit consideration of all the sites and manners in which cultural exclusions and dominations occur.

One direct manner of exclusion involves the cultural absence of any articulations of race, which in no way means that issues of race and racism did not exist. In relation to specific historical works and commentary, these absences permeate in implied egalities whose consequence means that race leaves no trace except in appearance and nomination.

Without the confirmation of Asian-ness in Paul Wong and Taki Bluesinger's surnames, Sara Diamond's mention of *New Era Marathon* (1974), with the vivid image of an Asian man running down Vancouver streets, might have gone unnoticed by me for this research.

> Taki Bluesinger ran from Vancouver to the Burnaby Art Gallery to open the exhibition he and Gilbert had curated, while Gilbert and Paul Wong encouraged and videotaped Bluesinger from the back of an accompanying pick-up truck. Taki marks each new kilometre with a change into a fresh T-shirt....[25]

24 Fung, "The Trouble with 'Asians,'" 126.

25 Diamond, 54.

A 1979 review in *Centrefold* by John Greyson pointed me to Lily Eng's *Defending the Motherland* (1979),

> A documentation of a performance: she exercised for eighteen minutes: she was eight and a half months pregnant.... Defending the motherland by challenging the clichés of motherhood — every movement a denial of the traditional passive role of pregnant women waiting nine months for deliverance.[26]

While I was able to locate a video still in the 1979 *Living Art* catalogue, which confirmed her Asian heritage, it was her surname that first offered the possibility for consideration for my essay.

26 John Greyson, "Initial Response," *Centrefold* 15 (June/July 1979): 272.

Neither *New Era Marathon* or *Defending the Motherland* focuses on Asian Canadian identity, nor do they express any particular aspects of Asian-ness. And there are many works that I could cite in this regard, such as Tomiyo Sasaki's *Spawning Sockeyes* (1983), or Ken Lum's video-performance, *Air* (1979). Fumiko Kiyooka's *Akumu* (1985), or Ken Kuramoto's *The Blue Mule Interviews* (1985), do so in subtle manners in content, respectively: the reference to atomic warfare, and *Blue Mule's* interview with artist and poet Roy Kiyooka. But for historical purposes, would these works be less valid for discussion because an Asian identity did not overtly predominate and define their content? Would the absence of direct articulation about race and culture hinder their ability to contribute to discussions of race and culture?

Within a wider context of emergent other voices within mainstream culture, the state of affairs at this particular historical moment (1992: Quincentennial of the "Discovery of America" by Christopher Columbus) is overwhelmingly characterized by the emergence of histories that were always there for half a millennium: histories parallel, submerged, subsumed. In the counter-Quincentennial activities that claimed a historical and contemporary presence for indigenous cultures flourishing when the "discovery" purportedly occurred, the

recuperating of these lost histories profoundly speaks the violent ways in which conquest, colonialism (and more insidiously, a neo-colonialism) not merely effaces, but also engages those cultures it wills to dominate. The dual requirements of a cultural critique must encompass both an expression of the experience of the oppressed in the writing of another history, but also a condemnation and dismantling of the colonial mentality.

In conclusion, there are two points that that should be explicitly drawn out. The first pertains to how the social exigencies of sexism, homophobia, and racism manifest themselves across silences within our culture, thus demanding overt significations with strategic politicizations of identity. As identity politics have become increasingly complex, it is evident that identities shift as affiliations intersect contextually. What is implied in this formulation is that categorizations of racial identity are ideologically constructed ones, which may, like their real social effects, be deployed toward strategically political ends.

The second point is to consider how such politicizations become contained. How do such identifications impinge on practical strategies of cultural production? In other words, to initially empower certain identities does not require that these identities merely integrate into structures of (white) identifications. Neither must interceptions occur in a manner organized around these identifications. In this regard, writes Trinh T. Minh-ha:

> ... the reality of the humiliated can never be exhausted, but as a strategy, its ends become limited. The corrective stance adopted to rehabilitate the image of the other through a critique mainly focused on stereotyping in the media has become too self-sufficient, and therefore, too predictable to offer a productive place for analysis ... the indictment of the master's monologism and of the forms of power he circulates runs the risk of wearing thin as the words of resistance around certain themes on the

oppressed become too familiar to the oppressor. There is indeed, no small, worn-out subject, but only narrow predictable representation.[27]

In addressing representation as one site for interruption, Trinh suggests the manner in which the maintenance of a marginalized subjectivity becomes accommodated in dominant culture. But she also underlines the extent to which the arena of representation needs to be continually addressed. So should the arena of practical access. As my reading of Sara Diamond's self-constraints in addressing questions of race would indicate for us, without the self-determination of artists of colour and First Nations artists, cultural domination by (white) structures of production, criticism, and histories would not be ruptured. And this presence depends on the politicized identifications of race because of the persistence of the otherwise unspoken ideology of whiteness.

27 Trinh T. Minh-ha, "The World as Foreign Land," in *When the Moon Waxes Red* (New York: Routledge, 1991), 190.

Are the larger aims for a cultural politics of difference to forge a space for a handful of video artists or filmmakers who are Asian, Native or Black (etc.), and enable increased access to the tools of production and exhibition and distribution or dissemination? This is of course the significant first step. Strategies for inclusion might further undertake rectifying a history already written, to redress the exclusion of artists of colour. But it is also important within a cultural context to distinguish these goals of increased accessibility, rectifying racist or absent representations from engaging how and analyzing why such absences and exclusions were and continue to be present.

Remaining comfortably celebratory and empowered in self-defined marginalized subjectivities with regards to a writing, or reconsideration of history, then, may be to adhere to a marketing strategy of history writing — or to employ a more palatable term, to simply hope for inclusion, accommodation, and a slight modification of an already-existent history. My point here is to polemically underscore some of the implications of conflating strategies for inclusion in the practical

arena of access and representation, with what we might want and what we might gain from a historical and critical discourse that dismantles silences around race and racism. To defy, then, Martha Rosler's fatalistic prediction, and force a convergence between art and social histories.

Diamond and Rosler productively demonstrate the exigencies of race in their textual blindspots and unconscious repressions, which at best, contain, and at worst, refuse the presence of racial difference in their own critical constructions of histories. At what cost? That dominant paradigms of unracialized historical, visual, and other discursive representations prevail and continue to be legitimated in purportedly critical contexts.

The implications for an examination of history engaged and informed by race and cultural difference is that excavations cannot effectively occur with the direct search for one's subject, for as a subject, she exists in complex and circuitous ways. This subject must be constructed at the very site and precise sign of cultural repression and representational absence — within a symbolic social economy in which paternalistic orientalist images proliferate without political analysis. And the pressures for the writing of an alternate history are that such a project cannot productively occur in the formations or the structures already written, not without an attentive reading for meaning in the absences, erasures, elisions, and conspicuous silences of race.

Dana Claxton
Waterspeak, 2000
video installation,
Artspeak Gallery, Vancouver
Photo credit: Kim Clarke

Dana Claxton
*The Heart of Everything
That Is,* 2000
video installation,
Kamloops Art Gallery
Photo credit: Kim Clarke

MONIKA KIN GAGNON

Dana Claxton
Buffalo Bone China, 1997
installation view and detail
of smashed plates
A.K.A., Saskatoon
Photo credit: Bradlee LaRocque
Collections of Mackenzie
Art Gallery and Winnipeg
Art Gallery

Sharyn Yuen
Sojourner, 1992
installation view and detail
sandblasted glass, photo
transfer, wood, steel
six panels, each 61 x 91 cm
Photo credit: Kim Clarke
Collection of the Kamloops
Art Gallery

opposite page
Nhan Duc Nguyen
Self-Portrait, 1992
photograph laminated
on plexiglas 91 x 183 cm
Photo credit: Kim Clarke
Collection of the Kamloops
Art Gallery

MONIKA KIN GAGNON

Fumiko Kiyooka
still from *Akumu*, 1985
Courtesy of Video Out

opposite page
Henry Tsang
Utter Jargon, 1993
detail of flag
mixed media
Photo credit: Donald Lawrence
Collection of the Kamloops
Art Gallery

Shani Mootoo
still from *Her Sweetness
Lingers*, 1994
Courtesy of Video Out

opposite page
Shani Mootoo
Untitled, 1995
colour photocopy
Courtesy of the artist

MONIKA KIN GAGNON

Jamelie Hassan
*Si-murgh et la montagne
de lotus,* 1993
photo details and partial
installation view
La Chambre Blanche, Québec
Photo credit: Ivan Binet

MONIKA KIN GAGNON

Paul Wong
*Chinaman's Peak: Walking
The Mountain*, 1995
"Moongate" installation
view, The National Gallery
of Canada, Ottawa
Courtesy of The National
Gallery of Canada

opposite page
Paul Wong
*Ordinary Shadows,
Chinese Shade*, 1991
installation view
The Chinese Cultural Centre,
Vancouver
Photo credit: Paul Wong

Paul Wong
"The Producers,"
production still from
Confused, 1983
Photo credit: Carol LeFlufy

opposite page (top)
Paul Wong
production still from
So Are You, 1990
Courtesy of the artist

opposite page
Paul Wong
still from *So Are You,* 1990
Courtesy of the artist

MONIKA KIN GAGNON

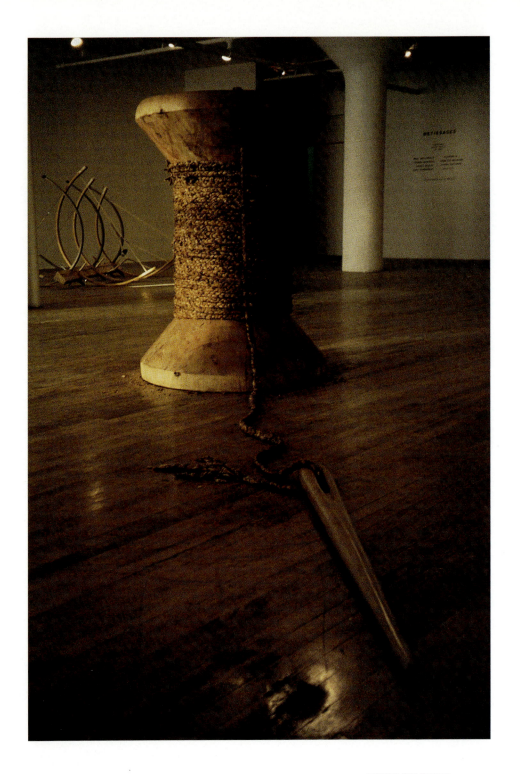

MONIKA KIN GAGNON

Teresa Marshall
Meta-Sage, 1994
5' wooden spool, tobacco,
4 needles: basalt, marble,
sandstone, limestone
Courtesy of the artist

thorough | race | | gold | but
long to | genus | | | yet

er, for those who have to work

nhàn-hạ phong-lưu, ở trong

oase-life | in easy circumstances | inside
| | indoo
ce who can afford to stay indo

Tàu, mà lăn-lẳn con ngu

china | and | slimer | off-spring | perso
| but | | bodly

the Chinese, slim and seldom

mắt thì đen và hơi xế

| eye | then | (black) | and | a little somewhat | oblic
| | brown | | slightly | slan

the eyes are dark brown and

uộm đen. Râu thì thưa

dye | black

MONIKA KIN GAGNON

Can-Asian, Eh?
Three Hyphenated
Canadian Artists

August 13, 1943: I read Canadian history and I'm learning a lot. I found out how Canada was built over four centuries by sacrificing native Indians. I was surprised that even in Canada there have been so many wars and struggles. That makes the theory of a democratic and peaceful Canada look hypocritical.
— Koichiro Miyazaki, from Angler internment camp, Ontario

Nhan Duc Nguyen
Self-Portrait, detail, 1992
photograph laminated
on plexiglas, 91 x 183 cm
Photo credit: Donald Lawrence
Collection of the Kamloops
Art Gallery

Where are the coolies in your poem, Ned?
Where are the thousands from China who swung their picks with bare hands at forty below?

Between the first and the million other spikes they drove,
And the dressed-up act of Donald Smith, who has sung their story?

Did they fare so well in the land they helped to unite?
Did they get one of the 25,000,000 CPR acres?
Is all Canada has to say to them written in the Chinese Immigration Act?
— F.R. Scott, "All the Spikes but the Last"

Coinciding with the centennial anniversary of Kamloops in 1993, the exhibition *Dual Cultures* might be thought of as exploring the imaginary question: What does Asian mean in Canada? The artists — Sharyn Yuen, Nhan Duc Nguyen, and

Henry Tsang — profoundly recognize the double-edged implications of this question. Their works commissioned for this exhibition respond with perspectives that are simultaneously subjective and historical, highlighting a complicated relationship between dominant and Asian cultures in Canada. If multiculturalism (introduced as an Act in 1971) is meant to celebrate the "other" cultures that comprise Canada's cultural mosaic, this exhibition, at its simplest, damages the cheerful but fictional cohabitation of cultural heritages, exploring instead the troubled landscapes within which perceived "alien" cultures were and are conditionally received. This makes *Dual Cultures* a profoundly challenging and earnestly bold exhibition to culturally commemorate the centenary of this Canadian city.

Predicated on the Asian-Canadian identities of its artists (or perhaps more generally, as colourful *non*-white Canadians), the title *Dual Cultures* underlines a duality and plurality which seeks to contain and separate (only) two cultures in the comfort of their distinction. The artists proceed with a doubled and ironic gaze that resists the separate cultures that the title *Dual Cultures* suggests. They are united by their critical identification as Asian-Canadians (not only their visible difference) and this politicized identification overtly informs all of their works. In this, Yuen, Nguyen, and Tsang complicate a clean duality and explore a space in between, a zone of contact and change, a collusion of cultures which produces a hybrid, an offspring of mixed cultural parentages: Asian, hyphenated space, Canadian.

As Sharyn Yuen's *Sojourner* most pointedly contemplates, this historical and contemporary landscape is fraught with blatantly racist government policies regarding the Chinese. For Nhan Duc Nguyen, born and raised in Vietnam until he was eight years old (emigrating first to the Philippines and then to Canada in 1976), examining his individual subjectivity and identity produces a wealth of questions. His works explore issues of linguistic and cultural translation, the constitution of national and political identities, further engaging vastly different but ideologically consistent representations of Asian

identity in a contemporary mediatized landscape. Henry Tsang delves into the history of the Kamloops area to find a landscape of complicity and contradiction in his examination of the linguistic phenomenon of Chinook Jargon, the pidgin language developed for trade purposes and widely in use until the early twentieth century.

These artists elaborate a space of overlapping cultures. This notion of overlapping rather than separate or dual cultures strongly challenges the definition of a Canadian culture predicated on a mosaic of unbalanced parts. Richard Fung writes, "While Trudeau's multiculturalism retains a special privilege for the language of 'the two founding races' (First Nations people are not counted among these) in theory it contains a recognition of the various cultures that comprise the country."[1] Yet the interdependence of linked cultural definitions is manifest in this recognition. For what the multicultural policy in part constructs through its legislation and administration is an inherent notion of what dominant Canadian culture is *not*. Multiculturalism has significantly shaped cultural funding policy, a shaping in which two definitions of culture are upheld. As Fung explains:

> On one hand we have the arts councils supporting an ahistorical, transcontextual "excellence" in capitalized art. On the other, the ministries and departments of multiculturalism promoting "the ethnics," with all the baggage and assumptions around non-Western, non-white as naive, static, and so on. It also goes along with the assumption and reinforcement around the kind of work, the kind of subject matter and the forms that people of colour should work with. Ballet is art, Chinese classical dance is multiculturalism.[2]

Multiculturalism embraces cultural differences, but in so doing clearly contains and manages them within legislated parameters. And it simultaneously masks, exposes, and protects the ethnocentric cultural norms that contain it. In exploring the historical, social, and subjective dimensions of

1 Richard Fung, "Multiculturalism Reconsidered," *Yellow Peril: Reconsidered*, ed. Paul Wong (Vancouver: On Edge, 1990), 18.

2 Ibid.

cultural difference in a Canadian context, the works of Yuen, Nguyen, and Tsang implicitly but powerfully articulate what is at stake in how we define and legislate Canadian culture. For what this embrace of cultural diversity masks in celebrating and containing cultural difference is the repressed history of racism that haunts and permeates it.

Consequentially, or the effects of an ideology of racism

In *John Chinaman*, a work from 1991, Sharyn Yuen constructed eleven jackets from white, hand-made paper — both paper and the colour white are elements associated with death in Chinese culture — upon which images and statistics from the Canadian Chinese Immigration Act of 1885 were applied. While the suit jackets, with their uniform formality, elicit the government authority behind the Head Tax, the name "John Chinaman" represents a generic English name, a moniker perhaps used to overcome the diffiiculty for Anglophones to pronounce Chinese names. (In *Kamloops: A History of the District up to 1914*, Ruth Balf writes of Ah Wah, called "John Chinaman," who stayed in Kamloops after the gold-rush of the 1860s.3) Yuen's piece emerged from a discussion between Yuen and her father: "My father was a Canadian-born Chinese as I am. He once said to me that he could never forgive the discrimination he experienced growing up in British Columbia at that time. It is hard for me to grasp this suffering as I have not personally experienced such direct racism."4

The direct racism which Yuen's father experienced was systemically implemented into Canadian government policy only just over one hundred years ago. In 1884, a $50 Head Tax was designed to restrict Chinese immigration into Canada (the same year, the British Columbia government imposed a $10 settlement license for all Chinese over fourteen years old). This federal tax rose to $100 in 1900, and to $500 in 1903. In 1923, the Head Tax was replaced with the Exclusion Act that prohibited Chinese immigration altogether. This Act was not repealed until 1947, a period during which sixteen Chinese were admitted (permits were provided for diplomats [!],

3 Ruth Balf, *Kamloops: A History of the District up to 1914* (Kamloops: Kamloops Museum, 1981), 53.

4 Sharyn Yuen, "Artist's Statement," in *Self Not Whole* (Vancouver: Chinese Cultural Centre, 1992), 60.

clergymen, teachers, actors, merchants, and tourists). The repeal of the Exclusion Act, as two writers note, was "not because of Chinese militancy or radical ideological changes in Canadian politics, but because Canada [had to] yield to international pressure."5

Like *John Chinaman*, Sharyn Yuen's *Sojourner* further contemplates the immigration policies that mar Canada's history, as well as the hypocrisies of (but also perhaps the motivation behind) these policies within the social and economic climate of the period. For it was with the contracting of the Canadian Pacific Railway in 1878 that the British Columbia legislature voted that no Chinese were to be employed on any provincial public works (following the presentation of a petition signed by 15,000 B.C. residents). Despite this ruling, over 15,000 Chinese managed to immigrate to Canada to work on the railroad, undertaking the most physically hazardous labour. This large influx of new railway workers resided in temporary tent camps set up in areas close to worksites; one such temporary camp was at Savona, near Kamloops. By the completion of the railway in 1884, more than 600 Chinese workers had died (a conservative estimate by Andrew Onderdunk, the American CPR contractor who "imported" the Chinese workers between 1881 and 1884), equaling approximately four Asian lives for each mile of track.

Austere and solemn, *Sojourner* is comprised of six glass plates, each sandblasted with a single word and holding one image — the effect is that of tombstones, a graveyard in which various fragments of Chinese-Canadian history resonate. The panels are installed upright at floor level in a darkened room and gently lit with small, soft spotlights that in two instances throw the words — VOICE and CULTIVATE — into shadow on the floor and wall. This ephemerality of shadow is echoed in the fragility of the glass plates through which the viewer must move.

The word ISOLATE is coupled with an excerpt from the Chinese Exclusion Act, detailing the guidelines for defining "Chinese immigrant" by the "controller" who was charged

5 Kwok B. Chan and Denise Helly, "Introduction to the Special Issue: Coping with Racism: The Chinese Experience in Canada," *Canadian Ethnic Studies* vol. XIX, no. 3 (1987), 11.

with determining entry or deportation. "But a person shall not be deemed to be of Chinese origin or descent merely because his mother or his female ancestors or any of them are or were of Chinese origin or descent," reads the excerpt, cryptically exposing the inferior status that women held within this already racist context. What is also revealed in this quotation are the ways in which government guidelines constructed and restricted the authenticity of Chineseness that would determine admission into Canada.

The history of Chinese railroad workers and their contribution to developing the railway that would link B.C. with the Prairies is invoked directly in one plate in which the word CULTIVATE is coupled with a wide-angle photograph of a railroad track extending into the horizon. With this image vacant of people, Yuen further alludes to the historical erasure that has occurred around the presence of Chinese labour; a significant erasure that bears the painful mark of oppression. This absence grooms history and conveniently evacuates the racial exploitation experienced by the Chinese. They have been made invisible in the cultivation of this country.

In TREMOR and VOICE, Yuen brings to light some of the faces that endured this repressed history, each strongly emblematic of the Chinese-Canadian experience. The word TREMOR is paired with the image of a large group of Chinese children and men restrained behind an ornate cast-iron fence (circa 1915 and thereby likely to be an immigration holding or detention centre). VOICE is paired with an identification photo-graph from a 1913 Head Tax certificate of a young Chinese man. He paid Head Taxes, purchased an identification card (for $500, now equivalent to $20,000), and his history is given voice by being passed on to Yuen by a friend who found it for twenty-five cents at a garage sale.

The word REVERIE, with its ethereal sense of daydreaming, is paired with beautiful fan-shaped Ginkgo leaves spread out on the earth and wet with raindrops. It reflects some positive aspects of the exchange between cultures, yet is also a metaphor for remembering displacement (the *Ginkgo biloba*

is an Asian tree brought to North America by immigrants, also used as a herbal supplement touted for its memory-enhancing properties). A historical continuum is again present in SILENCE, a word that immediately evokes the burden of unspoken history. SILENCE is juxtaposed with a photograph of a "No Trespassing" sign recently taken by Yuen at her neighbourhood public pool in Vancouver; the sign is defaced with graffiti that replaces "no trespassing" with "no chinks." Name-calling is but one of the most obvious forms of racism which *Sojourner* poignantly suggests to be an inevitable consequence of a racist history and ideology. As Kwok Chan and Denise Helly have suggested, Canada's legacy in official history is such that federal "Royal Commission inquiries remain today as the single most multi-faceted and comprehensive testimony of personal and systematic racism against the Chinese."[6] The image of racist graffiti mingles amongst the archival images, mobilizing the importance of historical memory in illuminating contemporary manifestations of racism. *Sojourner* reverberates with a poetic tension: the burden of a repressed Chinese history is marked by fragile, ephemeral tombstones, coaxed gently from shadow to light.

6 Ibid., 2.

Vicissitudes and the problem of translation

Nhan Duc Nguyen is represented by four separate but interconnected works all produced in 1992: *Who are we, where do we come from, where are we going?*, *The Blues, the Reds and the Yellows*, *Self-Portrait*, and *Fast Car*. The four works all draw significantly on Nguyen's experience of two distinctive cultures, Vietnamese and Canadian, moving through a subjective perspective to focus on clear points where the difficulties and subtleties of transposing cultural value become apparent.

Who are we, where do we come from, where are we going? delves into the complexities of being Vietnamese and the meaning of cultural nationality in a Canadian context. Constructed in a long row from a series of family portraits, Nguyen uses a family photograph taken in Vietnam in 1974, in which he, his mother, sister, and brother stand before their

home and a handmade sign which states, "We do not accept Communism." Opposite, on the far right, is a recent family snapshot, now including his youngest sister, at a family gathering in their mother's living room. Together, the two portraits subtly but powerfully evoke the political exigencies and choices necessary for individual survival in war-torn Vietnam; traversing from the rejection of Communism as a public statement to the warm, familial Canadian space of the later portrait. Individual portraits of each family member occupy the centre and into each image the word PROOF is stamped. PROOF dramatically alters the personal quality of these snap-shot-like pictures, summoning now not only the realm of private memory (and the photograph as its trigger), but also the public domain of the photograph, its reality effect. The photograph can supposedly confirm positive, visible, objective *proof* of identification and occurrence.

In *Self-Portrait*, the question of identity, specifically a Vietnamese identity, emerges again as Nguyen superimposes a handwritten passage from a Vietnamese textbook that defines "Vietnamese" over a full-size, colour self-portrait in which he poses in a slightly self-conscious stance. The passages are translated from Vietnamese to English, a process that Nguyen highlights with an intermediary, literal translation, which was consequently condensed and simplified. In showing the different aspects of the translation process, *Self-Portrait* comments on the effects of linguistic translation on cultural translation. Nguyen's text holds three lines — the Vietnamese, a literal English translation, and a grammatically corrected English text. All, in manifesto-like form, affiirm (and construct) the ideals of (and for) the Vietnamese people. (Its author, Tran Trong Kim, is considered to be a protector of culture, and was elevated to the status of deity.) The texts are handwritten on acetate, superimposed, juxtaposed, written across his portrait, his body.

One sentence reads: "Vietnamese, from North to South, embrace one custom, one language, one... *ky-niêm*." In this passage, the nodal point, *ky-niêm*, exemplifies the compro-

mises of linguistic translation, operations, and limitations of language as carrier and producer of cultural meaning. Surrounding *ky-niêm* is a small satellite of English words, of which none is a precise translation. *Ky,* deployed as *ky-thuât,* is to narrate; *ky su,* to chronicle; *ky luc,* to record. *Niêm* is to remember, read, recite, say, chant. The final text hovered on "memory," but settled on "remembrance," as in "Vietnamese, from North to South, embrace one custom, one language, one (remembrance)…" The resonant complexity of the notes compressed in the final "remembrance" illustrates how the process of translation is not a one-to-one precise translation of the Vietnamese word into its English equivalent, but also the translation of one culture into another. Aspects of self and nationhood are forced to shift, aspects already only hinted at to the English reader with the intermediary choices offered and then eliminated midway through translation. Rudolph Pannwitz has commented: "Our translations, even the best ones, proceed from a wrong premise. They want to turn Hindi, Greek, English into German instead of turning German into Hindi, Greek, English. Our translators have a far greater reverence for the usage of their own language than for the spirit of the foreign works…."[7] *Self-Portrait* hovers uneasily in a zone that exposes how linguistic translation impinges on cultural translation, and in effect exposes its transformative capacity.

The word PROOF appears again in the poetic text of *The Blues, the Reds and the Yellows*, where several graphic elements are at play. Four vertical text panels flank alternating image and coloured text panels, forming a grid-like mural. Between the texts are mugshot-like photographs of Nguyen on a yellow background, and blue and red colour boxes holding single French and English words: *calme, luxe, volupté* and *see, hear, speak*. In *Fast Car*, Nguyen counterpoints the sensationalistic media portrait of a so-called drug peddler (twenty-seven-year-old Kim Huang Huynh's violent murder in 1991 was immediately cited as drug-related). *The Blues*… also explores the colliding worlds of Vietnam and North America, the

7 Rudolph Pannwitz is quoted in Talal Asad, "The Concept of Cultural Translation in British Social Anthropology," *Writing Culture: The Poetics and Politics of Ethnography,* eds. James Clifford and George E. Marcus (Berkeley: University of California Press, 1986), 157.

effects of cultural displacement, but from an initially subjective, first-person voice.

"Straddling surfboards," reads part of the text, "two AWOLS, baked in scented oils, recount wondrous tales of automation with photos as PROOF." If PROOF in *Who are we…* was the potential affiirmation of otherwise shifting, unstable political identities, in *The Blues…*, PROOF effects a collision of worlds pivoting on photographic documentation. The sun-bathing GIs impress the child on a Vietnamese beach with their snapshots of "back home," boasting evidence of automation and progress: food vending machines, telephones, and TVs — images and cultural values of that very world into which this child (the child of the 1974 portrait) will enter.

Nguyen's text is authored as a diary entry, a letter to himself during a visit to Qui-Nhon in 1992. Here, cultural contradiction is self-contained as a descent into memory, childhood recollections littered with small insects, cadavers, and American GIs, a cultural revisiting, now complete with camera: "…you are there with your F-stops and film canisters enjoying the flies and the heat. Did you even bring the nasty pills to clarify the water?" More than a mere tourist, Nguyen reverses the objectifying ethnographic gaze as "I" and "you" shift across expanses of time, geography, and cultures and collapse in a temporal space of self, synchronically marked by Vietnam and Canada. "The doctor says you're alright, it's just shock, and the boy on the hill — you and me — will one day grow out of it."

Mika kumtux Chinook wawa? Nawitka!
(Do you speak Chinook? Of course!)[8]

Henry Tsang's *Utter Jargon*, is a text-based work which revives Chinook Jargon, an intercultural language developed and used throughout the nineteenth century in the Northwest region of North America. A site-specific installation for Kamloops and the Art Gallery, this work is comprised of four components: eight colourful banners installed on the front exterior of the Gallery, salmon-pink text running across the front

8 All the Chinook Jargon sentences and their translation are drawn from Tsang's *Utter Jargon.*

Sharyn Yuen
Sojourner, 1992
"Cultivate" and "Isolate" (details) sandblasted glass, photo transfer, wood, steel six panels, each 61 x 91 cm
Photo credit: Kim Clarke
Collection of the Kamloops Art Gallery

next page
Henry Tsang
Utter Jargon, 1993
exterior installation
mixed media
Kamloops Art Gallery
Photo credit: Donald Lawrence
Collection of the Kamloops Art Gallery

MONIKA KIN GAGNON

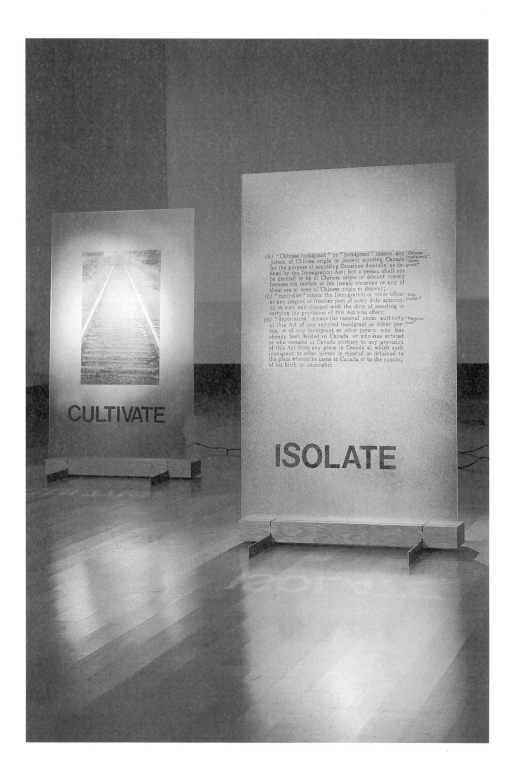

CULTIVATE

(b) "Chinese immigrant" or "immigrant" means any "Chinese person of Chinese origin or descent entering Canada Immi- for the purpose of acquiring Canadian domicile, as de- fined by the Immigration Act; but a person shall not be deemed to be of Chinese origin or descent merely because his mother or his female ancestors or any of them are or were of Chinese origin or descent;

(c) "controller" means the Immigration or other officer "Con- at any seaport or frontier port of entry duly appoint- troller." ed as such and charged with the duty of assisting in carrying the provisions of this Act into effect;

(d) "deportation" means the removal under authority "Deporta- of this Act of any rejected immigrant or other per- son, or of any immigrant or other person who has already been landed in Canada, or who has entered or who remains in Canada contrary to any provision of this Act from any place in Canada at which such immigrant or other person is rejected or detained to the place whence he came to Canada or to the country of his birth or citizenship:

ISOLATE

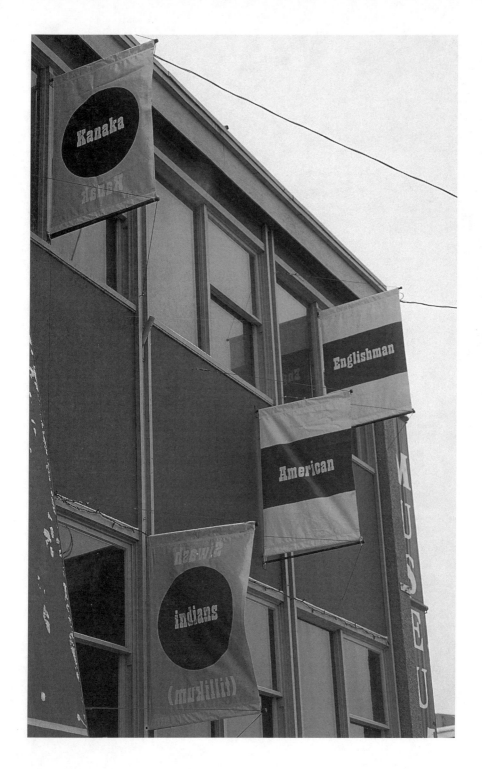

façade, two exterior electronic message boards, and calligraphy on parchment paper installed inside the gallery.

Utter Jargon reflects on Kamloops' centenary, reviving a language still in use at the time of the city's inception. Chinook Jargon was developed initially as a pidgin language among west coast First Nations peoples. Used primarily for trade purposes, Chinook Jargon's (roughly) 500-word vocabulary can be more specifically traced to the dialect of the Columbia River Chinook with further influences from English, French, and Nuuchaanulth (a First Nation located predominantly on the west coast of Vancouver Island). At the height of its usage, Chinook Jargon had an estimated 100,000 speakers throughout a region stretching from northern California to Alaska, and from the Rockies to the Pacific Ocean. As Tsang notes, the jargon was unable to resist the dominance of English, and fell out of use during the first half of the 1900s.[9]

> *Kanish mika chako? Chee nika ko.*
> (When did you come? I have just arrived.)

Utter Jargon is not simply a celebratory revival of a historic language developed around economics and trade some one hundred years ago. Lejeune's *Chinook Rudiments*, as a document of words in common usage in the Kamloops region, writes Tsang, "contains a list of the types of peoples who had come into contact with this area, and therefore had been given names to describe them." *Utter Jargon* focuses more specifically on the different cultures that contributed and were encompassed by this pidgin language.

Chinook Jargon can be understood as a product of what Marie Louise Pratt describes as a "contact zone." This zone, she writes, is a "space of colonial encounters, the space in which peoples geographically and historically separated come into contact with each other and establish ongoing relations, usually involving conditions of coercion, radical inequality, and intractable conflict."[10] Her use of the term "contact" is derived from linguistics, "where the term contact language

9 The Chinook Jargon and its English "translation" in *Utter Jargon* are drawn from Bishop Paul Durieu's 1879 *Chinook Practical Vocabulary*, later reprinted in Father Jean Marie Raphael Lejeune's *Chinook Rudiments* (1924). Lejeune, a missionary who was placed in charge of the Indian Mission in 1891, began *The Kamloops Wawa* (which existed for thirteen years), a newspaper published in Chinook Jargon, English, and occasional French.

Most of my factual information on Chinook Jargon is drawn from a flyer created by Tsang to accompany his installation. My quotations of Tsang are also from this flyer. He provides several bibliographic references, including: Duane Pasco, *Klahowya: A Handbook for Learning Chinook Jargon* (Washington: Poulsbo, 1990); George Coombs Shaw, *The Chinook Jargon and How To Use It: A Complete and Exhaustive Lexicon of the Oldest Trade Language of the American Continent* (Seattle: Rainier Printing Co., 1909); and Edward Harper Thomas, *Chinook: A History and*

refers to improvised languages that develop among speakers of different native languages who need to communicate with each other consistently, usually in a context of trade."[11] (She adds that these languages were perceived as "chaotic, barbarous, lacking in structure." Nonetheless, communication was made possible.)

> *Mika tikegh Boston wawa? Wake.*
> *Kahta? Halo shem mika? Wake. Cultus kopa nika.*
> (Do you understand English? No.
> Why? Are you not ashamed? No. It is nothing to me.)

Tsang's use of a "memorial" letter presented to Sir Wilfred Laurier by the Native chiefs of the Shushwap, Okanagan, and Couteau during his 1910 visit to Kamloops highlights the official engagement between indigenous peoples and their colonizers. Two sentences from the letter are represented three ways: in the original English (on an electronic message board), in Chinook Jargon translation (in salmon-pink lettering), and translated back into English from the Chinook translation (on another electronic message board). The English letter comes full circle through Chinook Jargon back into English, but through this subsequent translation, is altered. While the basic meanings are retained, the syntactical difference between them (the translation reflects a more spoken form of language) also creates subtle shifts in emphasis: "As long as he shows no hostile intentions" becomes "if his heart is not bad."

In the gallery, Tsang poses ten questions and answers in Chinook Jargon and English, presented on parchment paper in a calligraphy characteristic of the handwriting script of 1893. They reflect rudimentary points of discussion that also suggest the recurrence of contact. Like the subtle shifts in emphasis in the circular translations, these bilingual texts resonate the dialogues of different peoples, suggest a space of contact where different cultures might continue to cohabit. The austere selections of words in the exterior banners, however, are clearly chosen for the harsh contrast of meanings

(note 9 continued) *Dictionary of the Northwest Coast Trade Jargon* (Portland, Oregon: Binfords and Mort, 1935).

10 Marie Louise Pratt, *Imperial Eyes: Travel Writing and Transculturation* (London: Rout-ledge, 1992), 6.

11 Ibid.

effected by the translations. Chinook Jargon's "King George" represents Englishman, "China man," chinaman, and "Klale tillikum," literally meaning black people, has been translated by Bishop Paul Durieu into the English, "niggers." What Tsang consequently draws out is how Chinook Jargon embodied and reflected shifting relations of power between various culturally diverse groups living and working across this region. Further revealed is how cultural, political, and ideological entanglements inhabit the process of translation and the use of language. What clearly emerges are questions about the increasing dominance of racist ideologies of whiteness under the colonizing English and French, and what would, as Tsang states, eventually lead to the dominance of English and 12 Ibid., 11. the disappearance of an intercultural language.

Utter Jargon poses a galaxy of relations that are profoundly rooted in notions of power, sometimes contradictory, often complicit. Pratt's use of the term "contact," she writes, is "to foreground the interactive, improvisational dimensions of colonial encounters so easily ignored or suppressed by diffusionist accounts of conquest and domination."[12] As with Tsang's selection of Chinook Jargon terms and sentences, the "interactive" cultural context that is mobilized (and that Pratt might have us consider) is an exceedingly complex one, in which not only First Nations peoples, and English and French "traders" (or more accurately, colonizers) would engage, but one in which the "China man" (presumably standing in for all Asians, including women, we might gather), and "Klale tillikum," black people (then acceptably translated as "niggers") were also present. Chinook Jargon's "Siwash (tillikum)," translated into the English "indians," is derived from the French *sauvage* (or "savage," both rooted in the Latin *silvaticus*, belonging to a wood, wild), demonstrating the chaotic cultural relations at work in this complicated linguistic and economic orbit. For what is suggested is that, in Chinook Jargon, Native speakers would refer to themselves with a term derived from the colonizing French language. With the "Siwash (tillikum)," English "King George," American "Boston man," and French

"Passayoox," as well as "China man" and "Klale tillikum" inhabiting and moving through this region, one can only wonder, as *Utter Jargon* provokes, who was "Canada man"?

> When the words of the master become the site of hybridity
> — the warlike sign of the native — then we may not only
> read between the lines but even seek to change the often-
> coercive reality that they so lucidly contain.[13]

Dual Cultures might be understood as posing interruptive questions to the unified notion of a Canadian culture that creates and marks its boundaries by constructing an officially multicultural space. These three artists challenge the cultural place from which histories are written, where authority is assumed and exerted. They challenge by effectively undermining the channels and signs through which that very authority is manifested. For Yuen, this is a challenge to the cultural authority that excises Chinese-Canadian history in order to groom a tidier, democratic one. Nguyen unveils the inadequacy and limitations of linguistic translation in the translation of cultures, by constantly displacing the site of the authoritative "I," and in this, he destabilizes the possibility of myopic cultural values. Tsang invests linguistic translations with its relations of power, but clearly as an ambivalent power wherein the Native speaker will herself simultaneously assert the authoritative French colonial "I" that will address, expel, and contain her self as *sauvage*. Chinook Jargon disappears under the dominance of English, and as Talal Asad maintains, it is the political-economic dimension of language (in this instance, English) that must be underlined and addressed, for "Western languages produce and deploy *desired* knowledge...."[14] But this desire also speaks its lack.

For the unitary voice of command is interrupted by questions that arise from the heterogeneous sites and circuits of power which, though momentarily "fixed" in the authoritative alignment of subjects, must continually be represented in the production of terror or fear — the paranoid threat from the hybrid is finally uncontainable because it breaks down the

13 Homi K. Bhabha, "Signs Taken for Wonders: Questions of Ambivalence and Authority under a Tree Outside Delhi, May 1817," in *"Race," Writing and Difference*, ed. Henry Louis Gates, Jr. (Chicago: University of Chicago Press, 1986), 181.

14 Asad, 158.

MONIKA KIN GAGNON

symmetry and duality of self/other, inside/outside. In the productivity of power, the boundaries of authority — its reality effects — are always besieged by "the other scene" of fixations and phantoms.[15]

Homi Bhabha has written how difference and otherness are not outside, nor entirely oppositional to the authority of the dominant, but rather, "is a pressure, and a presence, that acts constantly, if unevenly, along the entire boundary of authorization…"[16] He elaborates the ambivalent presence of authority, that is, the manner in which that very enunciation of authority speaks its own ambiguity in disclosing its rules of recognition ("those social texts of epistemic, ethnocentric, nationalist intelligibility"[17]) which (inadvertently and simultaneously) "articulate the signs of cultural difference and reimplicate them within the deferential relations of colonial power."[18] It is the process of enacting discriminatory effects (so that those discriminated against may be easily identified) that is revealing. It is in this very distinction of difference, then, that the hybridity of its objects is exposed.

A revisiting of Canadian history rejects a political multicultural context that disavows and represses its racist history and present. These artists foreground those blind spots of the dominant culture within which particular subjectivities are continually refused identification in the representations that constitute the real. They assert that it is not simply enough to affirm a space of cultural difference, and their works reveal the extent to which "Canadianness" is in a continual process of redefinition.

We might see the works in *Dual Cultures* as a constant pressure subverting the modifying function of the adjective, Asian, in Asian-Canadian. And thereby subverting the noun, Canadian, itself. They inhabit instead, the space of the hyphen. "The challenge of the hyphenated reality lies in the hyphen itself…" writes Trinh T. Minh-ha. "The hyphenated condition certainly does not limit itself to a duality between cultural heritages."[19]

15 Bhabha, 177.

16 Ibid., 171.

17 Ibid.

18 Ibid., 172.

19 Trinh T. Minh-ha, "Bold Omissions and Minute Depictions," in *Moving the Image: Independent Asian Pacific American Media Arts* (Los Angeles: UCLA Asian American Studies Centre and Visual Communications, Southern California Asian American Studies Central, Inc., 1991), 84-85.

Lexicon
(for Teresa)

Heterosis (het'er o'sis) *n.* [*heter(o)* + *-osis*] a phenomenon resulting from hybridization, in which offspring display greater vigor, size, resistance, etc. than the parents — **heterot'ic** (at'ik) *adj.* (W)

Hybrid, *n.* half-breed, half-blood, half-caste (**Mankind, Crossing**). (RT)

Hybrid vigor same as **Heterosis.** (W)

me-2 2b. Metis, from Greek Metis, wisdom, skill. (OD)

meta *pref.* 1. Indicating change or alteration: metabolism, metamorphosis. (C)

Meta-Sage *n.* sculptural installation by artist Teresa Marshall produced during *Métissages* artists' retreat at Saint-Jean-Port-Joli, Québec during summer 1994. Exhibited at *Métissages*, Optica, Montréal, Jan/Feb 1996. Materials: 5' yellow cedar spool; 4 darning needles: black basalt, white marble, red sandstone, yellow limestone; braided tobacco.

Metis (me'tis) *n.* 1. The satellite of Jupiter that is second in distance from the planet. [After Metis, consort of Zeus, from Greek *metis*, wisdom.] (AH)

métis (ma-tes') *n.* 1. a mestizo 2. often Métis. A person of Native American and French Canadian ancestry. [Canadian French, from Old French *metis*, of mixed race, from Late Latin *mixticius*, mixed. See **mestizo**.] (AH)

Métis, one of several historically variable terms (*michif, bois brulé, chicot, halfbreed, country-born, mixed blood*)... capitalized... not a generic term for all persons of this biracial descent but refers to distinctive sociocultural heritage, a means of ethnic self-identification, and sometimes a political and legal category... Biologically, métissage has gone on since earliest European contact.... "Our young men will marry your daughters and we shall be one people," Samuel de **Champlain** reportedly told his Indian allies.... (CE)

Métissage (metisa.) [Fr.: cf. **metis**.] Crossbreeding. Also fig. **1895** in *Funk's Stand. Dict.* **1959** *Times* 13 Aug. 97 He is, too, on historical grounds, a firm believer in the value of *métissage* — the cross-fertilization of civilizations. **1972** *Guardian* 8 July 91 Léopold Senghor, President of Senégal... is a great believer in the virtues of *métissage,* or racial mixture. (OD)

Métissage *n. m.* Biol. Croisement de races ou de variétés differentes, mais appartenant à la même espèce, et dont les produits sont les *métis....* Anthropol. et Ethnol. On ne possède aucune preuve de l'existence de races «pures»... la plus grande extension est l'Amérique... deux tiers du peuplement de l'Amérique latine... Japonais se sont même ajoutés au mélange... Rien ne prouve que le mélange des races ait des effets défavourables au point de vue biologique... assez rare toutefois que le métissage contribue à unifier véritablement des populations de race différente... (GLE)

Needle (ned"l) *n.* 10. any object roughly resembling a needle or its point in shape — *vt.* -dled, -dling 2. [Colloq.] a) to provoke into

doing something; goad; prod b) to tease or heckle. (W)

Sage² *n.* 1. A being revered for their profound wisdom — *adj.* Profoundly wise or prudent. (C)

Spool (spool) *n.* 1. a cylinder or roller, usually with a hole for a spindle from end to end and a rim at either end upon which thread, wire, etc. is wound. (W)

Teresa: *In one of the small colour photographs you have given me to write from you are perched on a chair leaning over a giant spool carved from yellow cedar with your tools in hand. Daylight floods through a large window behind you, illuminating your golden skin and hair; you bite your lower lip, your eyes are cast downward at work. Also behind you is a green chalkboard with diagrams of the spool and some notations.*

What eludes me, I know, is the aroma of tobacco which winds itself around the spool and through the four needles which are lain on the floor and which face inwards. In your studio, you unwrapped a large parcel of moist tobacco for me when I asked what the tobacco smells like, and you described how it is one of four healing medicinal plants, with sage, cedar, sweetgrass. And described to me how the four directions are part of a knowledge passed down from ancestors. Four peoples are four races.

Thread (thred) *n.* 3. an element suggestive of a thread in its continuousness, length, sequence, etc. [the *thread* of a story]. — *vt.* 1. a) to put a thread through the eye of (a needle, etc.) 5. a) to pass through by twisting, turning, or weaving in and out.

Quotations from the following works were cited in the text using the following abbreviations:

AH *American Heritage Dictionary*, 3d ed.
CE *The Canadian Encyclopedia*, 2d ed.
C Teresa's *Collins New Concise Dictionary*

GLE *Grand Larousse Encyclopédique*
OD *The Oxford English Dictionary*, 2d. ed.
RT *Roget's Thesaurus*
W *Webster's New World Dictionary*

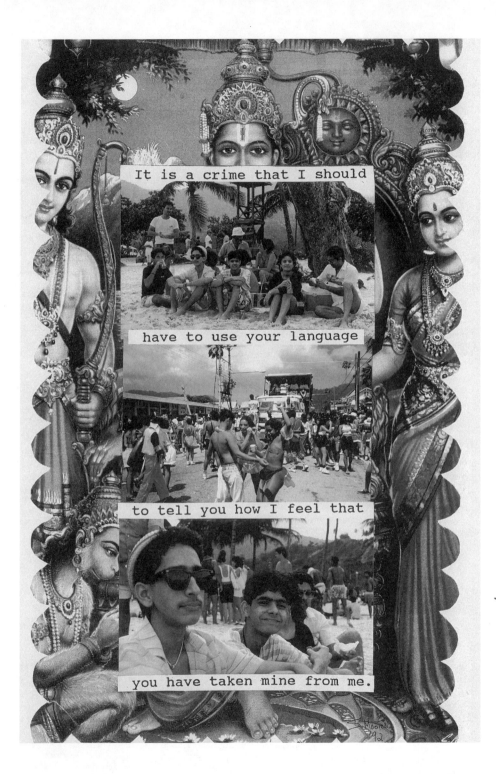

It is a crime that I should have to use your language to tell you how I feel that you have taken mine from me.

Out in the Garden:
Shani Mootoo's Xerox Works

"Listen to me... unless we can defy the natural order of all things that come into being let us not even begin. Let us not even begin."

— Shani Mootoo, *Her Sweetness Lingers*

Shani Mootoo
It is a crime..., 1995
colour photocopy
Courtesy of the artist

Since 1983, Vancouver-based artist and writer Shani Mootoo has been painting and writing and, more recently, making videos and colour Xerox works. Notable for her solo and group exhibitions over the last decade as well as for the publication of two books of fiction, *Out on Main Street* and *Cereus Blooms at Night*, a one-woman exhibition of Mootoo's work at the Contemporary Art Gallery, Vancouver, in 1994 gave viewers the opportunity to see a spectrum of Xerox-based works and four videos produced since 1991.

What is provocative in Mootoo's *œuvre* is her working across different media; the exhibition reveals the disciplinary range of her practice. Most simply, what is foregrounded is the writerly quality of Mootoo's visual and video work — the frequent use of text, the aural voice-overs in the videos — and the highly visual dimension of her writing — the distinctive and lavish atmospheric detail in her texts and fiction. More complex to consider, however, is the consolidation of Mootoo's cross-disciplinary work as an implicit assault on the sanctity of borders. Opening up this space of boundaries

can be seen as happening in several ways: in artistic production initially, meaning the implicit defiance of rigid categorization of different forms of artistic practice, i.e., painting, image-text work, fiction writing; but also symbolically speaking, in the larger sphere of social exchange where representations of static identities and cultures circulate. No dearth of themes, here. Pertinent to Mootoo's works are discussions engaging constructions of race and culture, gender and sexuality, nationalisms and borders, and questions of landscape and nature. Both Mootoo's defiant means of production, and her creation of a symbolic field in flux, insist that no such categories are allowed to remain stable or be ordered in simple hierarchies.

Formally, a disciplinary irreverence can be read in Mootoo's use of the Xerox itself, that multiple image-maker, the photo-*copy* that profoundly challenges the originary value ascribed to auratic gestures of the artist. Mootoo's cross-disciplinary practice speaks more to the limitations of any one medium in reconceptualizing the social order that she im-agines as possible. In the montage technique of the Xerox works, fresh flowers are scattered, old snapshots and other images cut and pasted, sliced and reversed, multiplied and folded, blown-up and shrunk. Consider what is pressed on the Xerox glass for mechanical reproduction: crayfish and squid, flora and seeds, and her own body: hands, feet, thighs, and genitals. What could be more contrary to the anonymity of the infinitely copied image than fresh food and flowers, or hands and feet suggesting a fragility of the body, the warmth of a touch? What could be more contrary to the alienating effect of this multiple than the profound intimacy of the genitals themselves? But this may be to ascribe a privileged place to organic and *natural* elements in works that themselves fundamentally recognize the effects of construction on all aspects of social life, including nature.

What is also provocative of Mootoo's *œuvre* is its ability to create complex relationships and complicities between vast social and cultural territories. (Consider, just simply, the

implications of Indian Pizza, a culinary collision to which Mootoo is especially endeared.) Distinctive of her works is a gentle prodding, an erosion of what is expected by us as viewers. Offering fragments of insights into different worlds, as Mootoo's works do, is a gesture complicating any momentum of our certainty as viewers, a certainty of the positioning from which we see and read as social subjects. Through copious detail, the work provocatively opens spaces *across boundaries*, creating an economy that is cross-disciplinary, cross-cultural, cross-gender, and cross-sexuality. The pervasiveness and insistence of particular social constructions appear only to disintegrate, slide away, undo themselves.

In the video *Wild Woman of the Woods* (1993), a goddess-like figure, bejeweled and draped in South Asian sari and scarves alluding to the lures of the enigmatic Asian woman, entices Pria into the depths of the forest. As part of her performative seduction — and this exemplifies Mootoo's ability to create recognizable representations only to undo them — the goddess later appears cross-country skiing to move across the snow-covered forest floor. With comic disruption she suddenly keels over, hardly commensurate with her image as enchantress.

On the "Ad Wall" located at the back of the gallery, one of an array of colour Xeroxes collaged to the wall, is a book image of copulating seahorses (also montaged is a newspaper shot of a baseball player in mid-swing, a restaurant advertising Indian pizza, colourful snapshots of costumed dancers from a Trinidad carnival). The appropriated book page describes (in an image reversal that flusters any easy reading) the insertion of the female ovipositor and the ejaculation of her eggs into the male, destabilizing the "natural" association of acts of penetration with the masculine in a heterosexist economy. "I'd rather not be a theory" intersects boldly across the seahorses.

In Mootoo's short story, "Lemon Scent," Anita asks her lover, Kamini, if she slept with her husband the previous night, to which she responds: "I am his wife, you know! What am I supposed to do? Say no all the time? I am married to him.

I can't always say no every time he wants to make love…" In "Wake Up," Angenie agonizes about a dream in which she has intimately kissed her mother on the mouth. "What inside me could have created such a dream?" she asks in repulsion, sexualizing the maternal body with a social contrariness that deeply startles even its own dreamer. Desire here, transgresses the sanctified social body, bringing its own longings into question.

> You are moving. You never stay still. You never stay. You never 'are.'
> — Luce Irigaray, *When Our Lips Speak Together*

> This land stretches in front of me, behind me and forever. My back feels exposed, naked, so much land behind, and no fence ahead.
> — Shani Mootoo, "A Garden of Her Own"

Whether in Mootoo's Xerox works, videos or fiction, vegetation is central, a recurring context and presence. In "Lemon Scent," a remote and shielded location of a back garden serves as an intimate shelter for lovemaking, a retreat from which Kamini and her lover, Anita, peer back towards the house where Kamini's husband, only moments earlier, had threatened her: "He says that he'll kill us both if he ever finds out about us." The space of the garden, as in another story, "A Garden of Her Own," triggers descriptive tactility, a sensuousness metamorphosed into sanctuary.

Such observations in the short stories are merely a preamble to considering the profusion of foliage in the visual and video works. If the space of the garden operates clearly in the short stories as a space of escape and refuge, its presence is far more complicated in the visual works. What are we to make of this imagery replete with flora and greenery? What are we to make of its repeated conflation with the sensuousness of the woman lover's body in the three untitled "berry" works?

Mootoo's gardens are distinctively female spaces, more specifically in *Her Sweetness Lingers* (1994) and "berry" works,

distinctively lesbian spaces. These gardens might be considered in several ways. Firstly, they could be understood in the genre of feminist Utopias that valourize exclusively female worlds. (Consider such valourization in Luce Irigaray's notion of *écriture féminine*, which privileges a specifically feminine pleasure, writing, and identity; or in a more Marxist vein, Monique Wittig's *Les Guérillères*, which prescribes a violent overthrow of the masculine by lesbians, heterosexual women, and gay men.) Secondarily, the gardens can be seen as summoning a nostalgia that offers no respite due to an awareness of the culturally constructed, idealized, and impossible state of nature in representation, and by implication, then, of gender and femininity. There are several substantiations for this latter self-consciousness. In the video *A Paddle and a Compass* (co-produced with Wendy Oberlander in 1992), the woman's voice-over confesses that her father has noticed her speaking in superlatives since she has moved to Canada. Alternating voices iterate descriptions of natural sites: the *highest*…, the *longest*…, the *coldest*…. Before Pria's ascent into the forest in *Wild Woman in the Woods*, her relationship to the landscape is at first hesitant, seemingly awed by nature's grandeur; a broad and *exaggerated* camera pan moves from Pria to her point-of-view, gazing upwards toward a foreboding Mount Rundle in the Rocky mountains which she will climb. In a characteristic Mootoo manner flustering even this example, Pria's ascent eventually leads her to a (South Asian?) woman's space, where three women join her to mingle and dance to Hindi film music, calypso-style.

This suggests to me a third possibility that broaches something between a naturalistic Utopia and the more cynical view of acculturated nature; for somewhere between sanctuary and a mediated state of nature is a possibility that these natural landscapes are *transitional* spaces between the harsh and inevitable bondage of all cultural constructedness and the sheer impossibility of separatist Utopias. These transitions continually let slip and rediscover a value in a tenderness of gesture, the tactility of odiferous camellias and ginger lilies, the

softness of moss underfoot, the texture of lips inside lips...

But such readings are perhaps too definitive for these works, too final, too desirous of closure. Let us suspend, then, some sense of how vegetative and floral spaces are all of these: Utopic sanctuary, cultural construction, and projection of fantasy, a space which might offer tranquil pleasurable refuge, a place for playful bondage and exquisite shivers.

> In a global cultural economy all constructions are exportable and importable: recipes for food, slogans, and gender roles are all reproduced as intrinsically theatrical significations.
>
> — Marjorie Garber, "The Occidental Tourist: *M. Butterfly* and the Scandal of Transvestism"

Mootoo has described "I'd rather not be a theory" as a centrepiece to the exhibition, suggesting her own aversion to pigeonholing definitions and her attempt, instead, at creating representations that are in states of movement and flux. Collaged directly onto the gallery wall amidst a profusion of cultural signs — sports pictures, food ads, snapshots of carnival — the vast terrain Mootoo makes operational is one that effectively disrupts the borders of these social fields and the strictly constructed identities within and across them: sports culture, food culture, science culture, botanical culture, culture culture.

The untitled "landscape" appears on this "Ad Wall," and again (in a variation that includes a montage of Mootoo) as a large mural consisting of twenty panels. In many ways, this Xerox montage most explicitly embodies the layered texturing and border crossings that underpin so many of Mootoo's works in this exhibition, bringing forth landscape and nature, the sexed and raced body, and representation itself.

At the centre of "landscape" is the coy, girlish, smiling face of Mootoo, head collaged onto a Teutonic-like, semi-nude, male and female composite from Dr. Marten's underwear boxes. She is backed by a floral splash, surrounded by an

almond-shaped, unmistakably labial, mirror-imaged and mon-
taged, pinkish, mountainous landscape, in turn surrounded by
intricately placed fresh flowers.

That many of the Xerox works make use of the self-
portrait, that Mootoo appears in voice and person in her
videos, and that the authorial "I" is present in so many of the
short stories, most immediately brings forth Mootoo's own
personal history, an autobiographical referent that must
inform any consideration of "landscape." These autobio-
graphical elements might be understood as having the same
oscillating and ambivalent qualities as Mootoo's represent-
ations of nature: as utopically questing for a sanctuary of Self,
but also simultaneously evoking the impossibility of rendering
a totality of Self in any representation. What is summoned in
"landscape" — if we understand the smiling, Indo Trinidian
Mootoo on the idealized, white, male / female body as a highly
provocative perversion — is the location of the Self as a *site*,
rather than as merely self-referential. The Self, then, is a site
of production of meaning, with subjectivity and identity itself
understood as being in a constant state of process and con-
struction. In this way, the border — as edge, side, line of
demarcation between frontiers — is the very territory that
exposes the permeability and precariousness of gender, sexual
and racial identities, and of the impinging social categories
that construct and maintain these subjectivities.

> ...*Cuando vives en la frontera*
> people walk through you, the wind steals your voice,
> you're a *burra, buey,* scapegoat,
> forerunner of a new race,
> half and half — both woman and man, neither —
> a new gender...
> — Gloria Anzuldua,
> "To live in the Borderlands means you"

Mootoo's work leads us into perceptually different para-
digms that expose the constraints of our own sexed and raced

identifications as viewers within existent social and psychic structures. Any sense of orientation in Mootoo's works is only temporary: gender and sexuality are undone, a purity of cultures challenged. The recurring movements against the grain effectively displace totalizing models of power that would pit the centre against transgressive margins, a margin-alization associated with disempowerment. What Mootoo's works create are alternate models of representation, not of cohabitation with or reaction to dominant representations, but alternative spaces that righteously assume new and complex definitions, therein asserting a space of imagined possibilities.

Shani Mootoo
Untitled, 1995
colour photocopy
Courtesy of the artist

MONIKA KIN GAGNON

The Possibilities
of Knowledge:
Jamelie Hassan

...as drops of water groove stone.

— Gayatri Chakravorty Spivak,
"Inscriptions of Truth to Size"

Jamelie Hassan
*Seek Knowledge even
Onto China,* 1995
colour photo from
installation,
Artspeak Gallery,
Vancouver
Courtesy of the artist

In her 1981 installation, *Desaparecidos,* Jamelie Hassan adopted elements from the weekly public demonstrations of the *madres de la Plaza de Mayo* who, during the brutal Argentinian military dictatorships of 1976–1983, donned white head-scarves asserting the names of missing relatives. Hassan's installation incorporated sixty-four porcelain pieces shaped like scarves, glazed white and inscribed in blue with the name and disappearance date of a missing Argentinian. A dossier of files (produced by *desaparecidos'* relatives) accompanied the porcelain scarf fragments. Originally presented to the Argentinian government to protest inaction and lack of investigation into the cases of missing individuals, the document made its way to London, Ontario and to Hassan, via the Grandmothers of the Plaza de Mayo who travelled to educate on their cause. Hassan's aesthetic mediation of the ritual scarves as fabricated porcelain objects rather than as actual scarves or photographic documentation, broached the impossible reconciliation between her empathetic affinity and the political realities of Argentina's torture camps, thus delimiting the boundaries of aesthetic intervention.

Ten years later in 1991, as American troops returned from
the Gulf War, Hassan placed the billboard work, *"Because
there was and wasn't a city of Baghdad,"* across the water from
Detroit in Windsor. Usurping the traditional site of advertis-
ing, Hassan set in motion a series of readings contesting the
naturalized construction of Iraq and, by extension, of the
Middle East, as the new post-Cold War enemies of American
democracy. Here, any assured representation of "Baghdad"
gives way to its mediatized fabrication, one that was crucial
for its destruction by American bombs. While at once lament-
ing Baghdad's civilian, architectural, and economic devasta-
tion, the public site of the billboard and the presence and
disappearance evoked by the text — the "was" and "wasn't"
of Baghdad — immediately accessed its mediated, public
representation, and in so doing, revealed the limits of media
in always advertising ideological content. This realm of the
simulated Baghdad underlined its ideological construction at
the hands of the American military apparatus, imagining its
fictive rather than factualized presence.

Underpinning Hassan's installations, as I have elsewhere
elaborated, is a theme that implicitly holds to the optimistic
possibilities of alternate modes of representation.[1] In explor-
ing the potential of culturally distinct forms of resistance and
protest — the *madres de la Plaza de Mayo's* scarves, the alle-
gorical object/"letters" from slaves in *Slave Letter,* the bill-
board site — the very fabric of Hassan's own artistic practice
can itself be recognized as a distinctive, alternative cultural
language.

The explicit power and threat of culture is directly observed
in several works aligned with controversial writers. (As I write,
I mourn the execution of Nigerian novelist/poet/journalist
Ken Saro-Wiwa, along with eight other activists on November
10, 1995, condemned to death for alleged incitement to murder
of four pro-government Ogoni chiefs.) *Inscription,* installed in
a display case situated at the main entrance to both the Dunlop
Art Gallery and the Regina Public Library in 1990, placed
Salman Rushdie's *The Satanic Verses* in the context of seven

1 My earlier "Al Fannanah 'l
Rassamah: Jamelie Hassan,"
discusses several of Hassan's
installations produced between
1983–88. In *Sightlines,* eds.
Jessica Bradley and Lesley John-
stone (Montréal: Artextes, 1994),
402–412.

other writers and books censored in the Arab world, including Naguib Mafouz's *The Beginning* and Nawal el Sa'adawi's *Two Women in One*. In Hassan's act of solidarity with Rushdie, condemned by Iranian Ayatollah Khomeini for his alleged blaspheming of the story of Muhammad's life, she makes clear the very real contesta-tory potential of language and reconfigured representation, but also, the tenuousness of its survival. Here, the literary text pushes into the realm of the sacred where its meanings and powers can now be challenged. "With such fragments," writes Gayatri Chakravorty Spivak in reference to *Desaparecidos'* scarf fragments, "is the substance of history mantled and dismantled in a series of everydays. Political art that respects this history, forever the present ruin of a past pushing into an intact utopia, changes minds as drops of water groove stone."[2]

The searching for a subtlety of language, form, and site increasingly imbues Hassan's works. *The Jamelie/Jamila Project*, Hassan's bookwork collaboration with Vancouver poet Jamila Ismail was produced during the period of the Gulf War. It departs from the simplicity of semblance between their names, "unfolding," as Larissa Lai has described, "paper, histories, personal experiences — of the quirky but powerful truths of the two women who created it."[3] A remarkable complexity emerges from this seemingly haphazard juxtaposition, collision, communion, of images, words, and objects (including a teabag, notebook, and bookmark), all evoking consideration of colonialism, resistance, and women's subjectivities through history. The result renders insight and power to the potential of (counter)systems of meaning and knowledge: the limits of imperialism's history gives way to a gendered everyday composed from juxtaposition and layering. The serendipitous slippages across cultures and histories, of which Jamelie and Jamila are only partly in control, seems to be the exact point. "The exploration of 'coincidence'" continues Lai, "is not in relation to each individual piece of text. It envelops the entire project." (The etymology of serendipity, incidentally, takes us back to *The Three Princes of Serendip*, a tale in which three

2 Spivak, 16.

3 Larissa Lai, "Doubling Identities," *Kinesis* (June 1993), 17.

princes make fortunate discoveries accidentally. It is frequently mistraced as a sixteenth-century Italian fairy tale, but actually originated from the earlier Persian.)

In many of Hassan's works — *Meeting Nasser, Citizen's Arrest* and *The Copyist* — as in Ismail's poem *Poeisis,* the inter-action with and close consideration of children offer sites for adult (un)learning and social rupture. In "Beading a Name" from *The Jamelie/Jamila Project,* Hassan alludes to conditions of entry into the Western social sphere, as she matter-of-factly describes how as a child her name had been changed by nurses and teachers, from (the more challenging for the Anglo-Western tongue) Jamelie, to Janey and Jeannie. *The Jamelie/Jamila Project* also contains an excerpt from Hassan's 1990–91 installation *Palestine's Children* which describes the practical idealism of a young artist, Salwa el Sawally, from Rafah Refugee Camp: "Her desire to retain her paintings in Gaza, despite offers of large sums of money from collectors, speaks to her belief that the painting she does is part of the commun-ity's history and that this work belongs to the residents of Gaza." In so doing, Sawally places her works within a local community of meaning and value, and outside of economic exchange relations.

Attentiveness to children's language and learning pro-cesses has the effect of denoting the limits of adult structures of meaning, socializing containers, which, through sheer weariness, perhaps, have become so naturalized. Marwan Hassan, Jamelie's brother, writes in his companion essay to Jamelie's installation, *Citizen's Arrest,*

> Civil society as it is manufactured occludes children. They know it and they resist this occlusion. Civil society is a pair of scissors trimming their wings. The conference of the birds does not occur in the adult world.[4]

It may or may not be coincidental to Hassan's *œuvre* that in early 13th-century Persia, Farid Ud-Din Attar was likely to have been tried for heresy late in his life, though not for his

4 Marwan Hassan, "Children and Social Space: Why Did Derrida Say No," in *Identity Transfers: Jamelie Hassan and Sarinder Dhaliwal* (Peterborough: The Art Gallery of Peterborough, 1993), 32.

poem *The Conference of the Birds*. There are many indications that this mystical poet's writings were deemed unorthodox in their Sufist orientations. The Western literary historian E.G. Browne dramatically wrote in 1902:

> Madharu'l-'Aja'ib, or 'Manifestation of wonders'...appears to have aroused the anger and stirred up the persecuting spirit of a certain orthodox theologian of Samarqand, who caused the book to be burned and denounced the author as a heretic deserving of death. Not content with this, he charged him before Buraq the Turkman with heresy, caused him to be driven into banishment, and incited the common people to destroy his house and plunder his property.[5]

5 E.G Browne, *A Literary History of Persia* (Cambridge: Cambridge University Press, 1969), 509.

6 Idries Shah, "Working with the Story," in *The Sufi Mystery*, ed. N.P. Archer (London: Octagon Press, 1980), 17.

Given this knowledge, the recurring use of paradox in Attar's *The Conference of the Birds* may have had a dual purpose. It suggests, first, a deliberate withholding of direct knowledge and how the mystical dimensions of Sufism were inadequately rendered in language (though perhaps most effectively through paradox). It may also have served to camouflage a belief system which contested Islamic orthodoxy and which could have resulted in the very reprisals which Attar would himself later suffer.

And there is the issue of the telling itself. Idries Shah tells us of the Sufi teaching-stories: "...they provoke, according to a certain alignment of the reader or hearer...."[6] The allegory of pilgrimage which underlies Attar's *The Conference of the Birds* describes the familiar spiritual journey motif of Sufism, in which there is a Path that is followed and a Guide who shows the way. In Hassan's *Simurgh et la montagne lotus, Chine*, this process of journey in pursuit of knowledge is layered with histories, not necessarily conceived of chronologically, but rather, explored spatially. The luscious photographs of Lotus Mountain suggest Hassan's own voyage to China. Intersecting the installations *Seek Knowledge Even Onto China* in its exploration of the linkages between the trading routes of ancient

silk roads, it also draws in Muhammad's statement, "Seek knowledge, even onto China," suggesting a trajectory through geographic space, in which China operates as a metaphor for exceeding any limitations on knowledge. The images of a Chinese palm-reader, in fortune telling, speak and herald the future into the present. Alerting us not so much to that which is unknowable, this structure of reading what is yet to come awakens us to our own possibilities of knowing, and the social, political, and aesthetic structures which delimit its range.

Jamelie Hassan
*Baghdad Billboard
Project,* 1991
London, Ontario
Photo credit: John Tamblyn

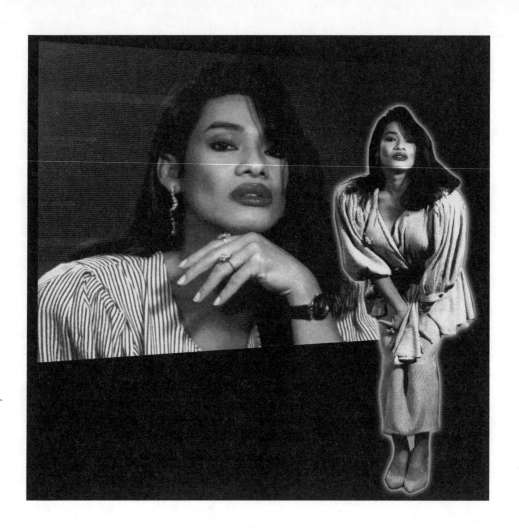

Go On, Push My
Discursive Limits:
The Ambivalence of
Paul Wong's Video Works

Michael Goldberg: *Do you have any secrets?*

Paul Wong: *They wouldn't be secret if I told you.*

M.G.: *I just want to know if you have any.*

P.W.: *Of course I do. My entire life is not an open book.*

M.G.: *You're putting out some personal things that do not put you in a good light. You're willing to do that. You do have an ethic about what one shouldn't put out. Where do you draw the line?*

<div align="right">

— Paul Wong,
interviewed by Michael Goldberg in *Centrefold*

</div>

Paul Wong
Mixed Messages, 1995
installation view,
The National Gallery, Ottawa
Photo courtesy of the
National Gallery

Given the interdisciplinary nature of Paul Wong's working method and its flamboyantly performative dimension, it is a complicated endeavour to compile information on his *œuvre* or to reconstruct the totality with any sense of certainty. This twenty-year body of artistic work consists of an array of single — and multi-channel video productions, cameo appearances and starring roles, performances, art installations, and curatorial enterprises — all part of Wong's ongoing practice as a multi-media artist. Archival elements proliferate: video documents, photographs, catalogues, exhibition and screening announcements, press releases, advertising, published interviews, commentary, and criticism. The works and archives are testimony to Wong's ongoing contribution to a burgeoning

video community positioned within the parallel network of
artist-run centres. His participation includes credited and
uncredited collaboration on innumerable video documents
and productions; the co-founding of the Vancouver video pro-
duction and distribution facility, Video In, in 1973; and the
organization of dozens of screenings and exhibitions, which
since 1985 have increasingly come under the auspices of On
Edge Productions, of which he is co-director.

Wong's multiple practices as an artist have thus centred on:
creating the material resources that have supported and devel-
oped alternative video production and audiences, through
such venues as Video In; curatorial work, including *Yellow
Peril: Reconsidered*, in which he employed identity categories
to showcase the heterogeneity of practices within the Asian
Canadian artistic community[1]; and his own interdisciplinary
practice, which has consistently challenged the transparency
of the media, dealing with issues of representation and the
construction of identity, desire, sexuality, and race.

The energy of the Vancouver Mainstreet working context
of the 1970s to early '80s, in which Wong was a central figure,
spawned a range of production.[2] The multi-channel installa-
tion, *Earthworks in Harmony* (1974), the autobiographical,
collaborative projects *"4"* (1981) and *Murder Research* (1977),
and the solo signature works *7 Day Activity* (1977) and
in ten sity (1978) stem from this period. In all these works,
video functions as a testament to a culturally productive
"lifestyle."[3] As singular artistic documents, the tapes contain
traces of the '70s artists' movement of which Wong was a part,
particularly in the multidisciplinary explorations of self, anti-
TV stances, and body art adventures.

The 1980s saw an aesthetic transition in Wong's videotapes
to more technically proficient productions that declared an
intent to "make product,"[4] as he has explained, within an
increasingly mediatized social environment. The glitzy *Prime
Cuts* (1981), *Confused* (1984), *Body Fluid* (1987), and collabo-
rative, mega-installation *Confused: Sexual Views* (prompting
a censorship fiasco that shook the Vancouver Art Gallery and

1 The exhibition *Yellow Peril:
Reconsidered* consisted of con-
tributions by twenty-five Asian
Canadian artists working in
photography, film, and video; it
travelled to six artist-run centres
across Canada during 1990–91.
See *Yellow Peril: Reconsidered*
(Vancouver: On Edge, 1990).
Exhibition catalogue.

2 As part of its twentieth-
anniversary programming in
1994, Video In presented two
nights of screenings, "Sculpting
the Deficient Flesh" and "Main-
street Mythopoeia," which exam-
ined the "unofficial affiliation of
artists" called Mainstreet Inc.
See Karen Knights, "Sculpting
the Deficient Flesh: Mainstreet,
Body Culture and the Video
Scalpel," in *Making Video "In"*
(Vancouver: Video In).

3 Jo-Anne Birnie-Danzker has
written of *"4"*: "Although the
performance purports to be
auto/biographical and reflective
of East End Vancouver, Main
Street Culture, the auto/bio-
graphy begins at the point where

166

the arts community in 1984) actively engage with mass media images, challenging mainstream stereotypes with experimental representations of alternative sexualities and social roles.

The construction of desire though the mass media was the subject of *7 Day Activity*, about which Wong stated: "This particular work relates to television: what is mass media beauty. The majority of people out there are striving for what is beautiful this year or month… I realize the effect it has on me. I like to see why I'm being manipulated, and I can show the other point of view, or the same point of view but slightly different."[5] Wong submits himself to a seven-day observation of his facial acne, using video as a mirror. He squeezes his pimples, applies various creams and exfoliants, to an accompanying aural and textual commentary that presents conflicting information about the causes and treatments of facial acne. If this tape expresses the relationships between representation, desire, and identity (and the pressures of adolescence in navigating these psychic terrains), it also broaches the issue of how dominant cultural ideals of white beauty impinge — in a contradictory manner — upon all social subjects. For desire is continually constructed and mediated through visual representations that privilege whiteness.

Throughout the video works there remains an elusive quality. The performative self-consciousness of the '70s "lifestyle" videos, for instance, unsettles the authentic appearance of autobiographical documentary. In the casual, technically rough, *verité* approach of the Mainstreet tapes or *"4"* a residue of constructedness prevails and is deliberately insistent. It is the clock on the dingy kitchen wall in *"4"* that reveals large time lapses, rupturing the otherwise convincing illusion of *verité* and real time as performers get even drunker and eventually stagger home. It is the interjection of Wong's own voice on the telephone in *Prime Cuts*, reprimanding one of his models/actresses for being late, or the sculpting of the repulsive *hors d'œuvres* in the party scene, that suggest a certain ironic distance. It is the repetitive presence of actress Deb Fong in a variety of roles — absent, gossiped-about Deb in *He, She,*

(note 3 continued)
the lifestyle was chosen. The choosing of (at times, fantasy) lifestyles in most West Coast performance (especially *haut camp*) is perhaps one of its most distinctive and generalized features." see "West Coast Performance: Praxis without Ideology?" in *Living Art Vancouver* (Vancouver: Western Front/ Pumps/Video In, 1979), 82.

4 All further unreferenced quotations from Paul Wong are drawn from various conversations with the author in 1994.

5 Michael Goldberg, "Paul Wong Interviewed by Michael Goldberg," *Centrefold* 2, no. 5 (June 1978): 56.

They (1976) and *"4"*; rifle-bearing, Chinese Red Army soldier
in *Body Fluid;* compliant, efficient secretary to the female

executives in *Confused* and *So Are You* (1995) — that makes
any authenticity of personality impossible. All conspire to pro-
duce an unease that situates the viewer in a space of uncertainty.
And the viewer's desire for anchoring, for simply knowing
whether what is being watched is fiction or non-fiction, auto-
biography or calculated performance, is repeatedly derided.

The tapes in which the categories of documentary/*verité*,
drama/performative fiction are most explicitly confounded —
in *Confused, Ordinary Shadows, Chinese Shade* (1988), and *So
Are You,* for example — are marked by a formal complexity.
They also have the effect of highlighting the complacency of
our own viewing practices by provoking a sense of ambiv-
alence. By ambivalence I do not mean to suggest ambiguity;
rather, this is an attempt to discern how Wong's videos work.
Through their refusal of fixed formal genres, they not only
disrupt the production of established meanings found in main-
stream stereotypes, but they also undermine the security of
didactic counter-images. Larissa Lai eloquently captured the
sense of fluctuating truth and meaning in *Chinaman's Peak:
Walking the Mountain* (1992):

6 Larissa Lai, "The Site of
Memory," in *Paul Wong* (Banff:
Walter Phillips Gallery, 1993),
5–6. Exhibition catalogue.

> Where the peak is and what it looks like are merely inci-
> dental. At the beginning of the tape a number of local
> residents and visitors present conflicting "truths" about
> Chinaman's Peak — how it got its name and who the
> "Chinaman" was. In the end, nobody knows for sure
> and none of the stories are true, or else they all are.[6]

Ambivalence is thus created through an inhabitation and
simultaneous rupturing of formal conventions. The process
also challenges simplistic notions of the politics of identity.
What emerges in Wong's tapes is an eruption of all trans-
parency through a destabilizing of formal medium. Identity,
sexuality, and race are displayed as social and representational
practices, as is our complicity as viewers in expecting and
receiving these images, whether stereotypes or counter-types.
The discursive limits of certain subject matters are further

revealed and pushed, exposing social and critical frameworks
that cannot see the boundaries they have themselves demar-
cated. (It is, of course, the power of all ideology to camouflage
its own production of meaning.) The effect is unsettling and
disturbing, as Wong's videotapes seem to suggest the inade-
quacy of social ways of knowing.

In 1982, Tim Guest quite adventurously wrote that *Prime
Cuts*, in exhibiting the leisure activities of a group of white
heterosexual couples, to an irritatingly upbeat soundtrack, is
in fact, "Paul Wong's tape about white people. It is about a
successful consumer lifestyle value system, and it is equally
about Paul Wong's desire for it, and his alienation from it. It
is the most thoroughly ambivalent work I know of."7 Guest
identifies a complicated quality within Wong's video works:
a simultaneous fascination with and repulsion towards their
own subject matter. To paraphrase Guest's insight and extrap-
olate just a bit further, Wong's approach in *Prime Cuts* does
not simply denounce the vacuousness of his subjects and the
culture from which they emerge; it represents them. And in
doing so, says Guest, Wong may be completely unaware of the
way in which he simultaneously articulates both his desire and
his own "contradictory and ambivalent circumstances."8

7 Tim Guest, "Intolerance (The
Trouble with Social Realism),"
Parallélogramme 8, no. 1
(Oct./Nov. 1982): 19.

8 Ibid.

9 Ibid.

The contradictory and ambivalent circumstances Guest
is pointing toward when he declares, "I believe this tape is
implicitly engaged in the manifest issue of racism and white
ethnic supremacy"9 are, I assume, the unspoken requisites of
whiteness. These preclude full entry into the leisure lifestyle,
at least as far as such is represented in the cultural mainstream,
in which Wong, as a Chinese male, can never participate un-
conditionally. Considered in this way, *Prime Cuts* could be
seen as delineating the discursive conditions of its own pro-
duction in a complex way. Not because Wong excludes himself
from the screen in this tape, but more interestingly, because he
only represents himself via telephone, which suggests the re-
strictions on admission into dominant visual representation.

The videotape *Confused* incorporates some "raw working
data" from the twenty-seven taped interviews that make up
the multi-channel installation *Confused: Sexual Views*, which

was banned as "not-art" by the Vancouver Art Gallery in 1984.[10] One consequence of the ensuing controversy was that the tape was never adequately released or distributed during the 1980s. *Confused* was described by Wong as a companion work to the later *So Are You*, and indeed the two show a remarkable thematic and formal similarity. While *So Are You* more explicitly contends with the production of racial stereotypes, the social construction of gender and sexuality figures prominently in it (as it does in *Confused*), through interweaving interviews with identical white male twins and a couple of drag queens, whose performances expose the gestural dimensions of femininity.

Both tapes anticipate Wong's most extreme interrogation of the naturalizing of gender and sexuality in *Mixed Messages* (1995), a two-channel installation comprising two sessions with transsexual Gina Gonzalez. Four years and an (alleged) sex-change operation separate the interviews. In the second tape, we observe Gina's responses as she watches the earlier (pre-operation) interview. *Mixed Messages* seems to epitomize the crisis, or precariousness, of sexual identity, as the biologically "male" and "female" versions of the same person face each other in video-induced mirror-warp. That Gina is a misogynist "female," strictly adhering to heterosexual practices as a transsexual ("Forget it," she responds to the suggestion of sex with a woman, "smells like fish, sorry…"), seems startling in light of her perfection of the full masquerade of femininity. Gina becomes enmeshed in other peculiar revelations: this Filipino Canadian has a preference for white, blond, and blue-eyed men only.

While *Mixed Messages* manages to embody the contradictions of sexual and racial identity in one figure, albeit a surgically manipulated one, the earlier tape, *Confused,* explores the option of bisexuality. Through a coherent, if loosely structured, experimental narrative, it captures a moment in the lives of two couples. Wong uses dramatized scenes to propel the narrative, stream-of-consciousness voice-overs, and "confessional" interviews to discuss sexuality. Jeanette and Paul's "open relationship" accommodates new same-sex lovers. These are Gina

10 The controversy and ensuing court cases over the cancellation of Wong's multi-channel installation *Confused: Sexual Views* at the Vancouver Art Gallery in 1984 has been extensively documented and discussed. See, for instance: Varda Burstyn, "The Wrong Sex," *Canadian Forum*, no. 741 (Aug./Sept. 1984): 29–33; Barbara Daniel, "The Balance of Convenience," *Parallélogramme* 9, no. 5 (Summer 1984); Sara Diamond, "Clear about Confused," and "Paul Wong Talks to Video Guide about the Making of 'Confused,'" *Video Guide* 6, no. 2 (March 1984); "Daring Documents: The Practical Aesthetics of Early Vancouver Video," in Stan Douglas, ed., *Vancouver Anthology: The Institutional Politics of Art* (Vancouver: Talonbooks, 1991); and Elspeth Sage, "Ethics and Art," *Parallélogramme* 12, no. 4 (April/May 1987). For documentation of TV media coverage of the event, see the video *Confused: The Controversy* (1984), by Robert Harvey and Stokely Seip.

and Gary, a married couple, now bisexual and each having
secret affairs. A crisis of revelation is provoked by a hilarious
disco encounter in which the "new couples" bump into each
other by accident. Gina and Gary are propelled into exploring
the "nature" of their marriage, their sexual desires and orienta-
tions. Sexual *practices* are at issue here, viewed as heterosexual,
bisexual, gay or lesbian, rather than as pre-determined, un-
changeable biological traits. The stability of any of these cate-
gorizing sexualities is undone, as the four romp happily in and
out of bed in a variety of configurations in the video's exquis-
ite closing shot.

 So Are You takes on the complex constructions of racism,
shadowboxing perilously with infinite variations on racial
identifications. As is true of many of Wong's other tapes, *So
Are You* doesn't lend itself to easy summary. It creates a highly
racialized "environment," beginning with appropriated news-
reel footage of global racial strife, moving on to interviews,
short dramatizations and vignettes, mock TV newscasts, in
which a recurring cast of characters rapidly circulates in diff-
erent roles that shift racial identities, stereotypes, and relation-
ships of power and disadvantage.

 An initially privileged, white male stockbroker and a fe-
male cultural administrator, around whom the tape is roughly
structured, end up as junkie and hooker, respectively. The
prostitute persona spews racialized stereotypes about love-
making styles of her East Asian/South Asian/Black/White
clientele, finally climbing into a Native client's red BMW. The
driver goes on to shoot two white working-class men taunting
the "Red Indian in the red car," an event which is then reported
in a mock newscast as yet another incident of Asian gang war-
fare, complete with a getaway in a "red Corvette." A Black
man smiles broadly and declares his love of watermelon and
fried chicken; later he gratuitously dribbles a basketball
through a sidewalk café scene. Alfred Ling announces his
"glorious and big" real estate developments in Chinatown;
while a Chinese woman — Deb Fong, again — transforms
herself from *Watchtower* magazine distributor to silent, subser-
vient secretary, and finally to a fur-clad Business Woman of

the Year. A Native woman, first spotted as an alcoholic in an alley scene, appears next as officious newscaster Connie George and makes an offensive joke about "white-trash" incest. Interweaving throughout are the interviews with the twins and drag queens, whose conflicts and commentaries accentuate the tenuousness and artificiality of social personae.

The stereotypes here are harsh and recognizable, the point being, I surmise, to demonstrate what Richard Fung has described as the fluid discourse of racism: "Whereas racism privileges whiteness and targets a somewhat shifting body of 'others,' anyone, no matter their status or colour, can engage its discourses."[11] *So Are You* bluntly illustrates this very point.

Over the last decade, one can catalogue a broad range of Canadian video productions by artists of colour and First Nations artists who identify themselves as such, and who take this identity as the point of departure and often the content of their work. While this characterization somewhat simplifies the complexity of a diverse body of work, my intention is to locate Wong's work within this prolific context. Contrary to Henry Tsang's assertion, in 1991, that "Wong has *recently* begun investigating the constructs of race and racism in his works,"[12] I want to suggest that Wong's earlier works provide the opportunity of examining the construct of "race" in ways that challenge the contemporary context. This is not to undermine the significance of this production, but rather to locate identity politics as a strategy *within* an ongoing transformative process wherein we imagine the future.

Wong's videotapes propose an alternate route of reading the multiple ways in which "race" is constructed. In this, they provocatively point to the boundaries and exigencies of identity politics that often require overt and reductive identifications at the risk of disavowing the complicated ways in which racialization, and consequently racism, is produced — both historically and currently.

The artist's work at multiple sites illustrates the complexities of strategizing for particularized political ends. *Yellow Peril: Reconsidered* was organized under the rubric of the identities of its Asian Canadian producers, rather than by media or

11 Richard Fung, "Seeing Yellow: Asian Identities in Film and Video," in Karin Aguilar-SanJuan, ed., *The State of Asian America, Activism and Resistance in the 1990s* (Boston: South End Press, 1994), 164.

12 Henry Tsang, "Self Not Whole: In Search of a Cultural Centre," in *Self Not Whole: Cultural Identity and Chinese-Canadian Artists in Vancouver* (Vancouver: Chinese Cultural Centre, 1991), 9–10. (My emphasis)

theme. It thus situated itself within an identity politics aligned
with feminist, gay, and lesbian cultural practices, which have
used various cultural tools to tackle social marginalization. In
its very title, *Yellow Peril: Reconsidered* self-reflexively indexed
the historical conditions that abetted racist governmental pol-
icy (such as the Chinese Head Tax of the late 1800s, or the
World War II internment of Japanese Canadians). The title
simultaneously reclaims the racist term "yellow peril" and
throws it into ambivalence. (Not unlike the reconfiguration of
the term "queer" in gay and lesbian empowerment. *Confused*
similarly embraces in its title heterosexist characterizations of
bisexuality as the disordering of "normal" sexuality.)

Paul Wong has remarked that he was always highly aware
of the blood-brother ritual in *60-Unit Bruise* (1976) as involv-
ing an exchange between yellow and white bodies. His self-
recognition as a Chinese Canadian male in his own video
works ranges from his laughing response to an inflatable
doll's dildo pressed against his face by Jeanette Reinhardt in
Confused ("White cock against yellow flesh!"), to his conver-
sation with Rick Erickson in *Ordinary Shadows* about how he
can modify his behaviour to be perceived as a "wimpy North
American" rather than a "wimpy Chinaman," as they travel
through China. In this latter instance, Wong distinctly denotes
his cultural difference and foregrounds his Canadianness with-
in the Chinese context, putting an interesting twist on the
romantic return to the country of origin.[13]

A far different tone informed the subject of Wong's
Chineseness in his venture into national primetime television
in 1994. On CBC's *Adrienne Clarkson Presents,* Clarkson repeat-
edly grilled Wong on his Chinese identity, a line of question-
ing that Wong would neither directly comment on, nor engage
in.[14] This amusingly evasive strategy implicitly refused the
reductive and marginalizing effect of "ethnic" identity within
mainstream culture. Having brought his own video camera
along, at one point Wong turned his camera over to Clarkson
— a shot from Wong's videotape that CBC actually cut in —
metaphorically highlighting how his own *œuvre* has actively
dialogued with mass media by restructuring its representations.

13 See Richard Fung's commen-
tary on Wong's video, "Everyday
People," *Fuse* 13, nos. 1/2 (Fall
1989): 55–56.

14 "Journey around the Moun-
tain," on *Adrienne Clarkson Pre-
sents,* was aired on CBC
television, 19 Oct. 1994.

The instantaneity of video, its ease of mobility, the possibilities of self-observation, of mirroring and voyeurism that characterize Wong's body of video works, seemed to coalesce as he was surrounded by monitors displaying his own tapes simultaneously.

Wong can perhaps best describe himself, as he does in his opening remarks to CBC's "Journey around the Mountain":

> Looking back in hindsight at the body of work, it's all been a search for identity... seeing that whatever was out there didn't reflect who I was... because I was young, because I was born in Canada, because I had two languages, because I didn't want to have traditional values, because I wanted to be an artist, because I wanted to feel things and see things in a different way, because I had different sensitivities. Gravitating toward video was like magic. The very first time I picked up a video camera, I knew somehow this tool that could record sound and voice — that I could erase and use very instantly... blow up... entertain friends with — was going to open doors for me, was going to become a vehicle for me.[15]

15 Ibid.

While Wong recognizes the search for identity as the underpinning force in his work, his tapes demonstrate the constant changeability of that process of self-definition. In exploring the languages and frameworks of representation, and the confining boundaries they create, Wong's works remain evasive and ambivalent towards the security of the counter-images he himself produces. Like a shadowboxer whose own likeness shifts at the decisive moment of each opposing motion, it is as if Wong's *modus operandi* lies in that precise instant of simultaneous movement, in which all becomes uncertain and gives way to infinite possibilities.

MONIKA KIN GAGNON

Filmography/Videography

Barco, Julia. *Pregnant with Dreams/Prenadas de Suenos* (1988). 48:00, video. Women Make Movies.

Bluesinger, Taki with Paul Wong and Gerry Gilbert. *New Era Marathon* (1973). Approx. 60:00, video. Video Out Archives.

Brand, Dionne and Claire Prieto. *Older, Stronger, Wiser* (1989). 27:59, 16mm film. National Film Board of Canada.

Claxton, Dana. *The Shirt* (1994). 6:00, video. Video Out.

———. *Tree of Consumption* (1994). 12:00, video. Video Out.

———. *I Want To Know Why* (1994). 6:30, video. Video Out.

———. *The Red Paper* (1996). 13:49, black and white film installation. Moving Images and Video Out.

———. *Buffalo Bone China* (1997). 12:00, video. Video Out.

———. *The Heart of Everything That Is* (2000). Video installation.

———. *Waterspeak* (2000). Video installation.

Eng, Lily. *Defending the Motherland* (1979). Courtesy of the artist.

Fung, Richard. *Fighting Chance* (1990). 29:00, video. V Tape.

Geddes, Carol. *Doctor, Lawyer, Indian Chief* (1986). 28:42, 16mm film. National Film Board of Canada.

Hamilton, Sylvia and Claire Prieto. *Black Mother, Black Daughter* (1989). 28:59, 16mm film. National Film Board of Canada.

Kiyooka, Fumiko. *Akumu* (1985). 5:00, video. Video Out Archives.

Kuramoto, Ken. *The Blue Mule Interviews* (1985). 47:49, video. Video Out Archives.

Mootoo, Shani. *The Wild Woman in the Woods* (1993). 14:00, video. Video Out.

———. *Her Sweetness Lingers* (1994). 12:00, video. Video Out.

Mootoo, Shani and Wendy Oberlander. *A Paddle and a Compass* (1992). 10:00, video. Video Out.

Onodera, Midi. *The Displaced View* (1988), 52:00, 16mm colour film. Video Out.

Prieto, Claire and Roger McTair. *Home to Buxton* (1987). 29:00. 16mm film. (Distributor unknown.)

Sasaki, Tomiyo. *Spawning Sockeyes* (1983). Video installation.

Sujir, Leila. *India Hearts Beat* (1988). 14:00, video. Video Out.

Todd, Loretta. *Eagle Run* (1989). 28:00, video. (Distributor unknown.)

Wong, Paul. *Earthworks in Harmony* (1974). 32:00, video installation. Video Out.

———. *Seven Day Activity* (1978). 13:00, video. Video Out.

———. *4* (1978-80). 45:00, video. Video Out.

———. *in ten sity* (1979). 23:00, video. Video Out.

———. *Prime Cuts* (1981). 20:00, video. Video Out.

———. *Body Fluid* (1987). 22:00, video. Video Out.

———. *Ordinary Shadows, Chinese Shade* (1988). 45:00, video. Video Out.

———. *Chinaman's Peak: Walking The Mountain* (1992). 25:00, video. Video Out.

———. *So Are You* (1994). 28:00, video. Video Out.

———. *Mixed Messages* (1995). Video installation.

Wong, Paul and Kenneth Fletcher. *60-Unit Bruise* (1976). 5:00 video. Video Out.

———. *Murder Research* (1977). 17:00, video. Video Out.

Wong, Paul and Jeanette Reinhardt, Gina Daniels, Gary Bourgeois. *Confused* (1984). 52:00, video. Video Out.

Bibliography

Allen, Lillian. "Transforming the Cultural Fortress: Imagining Cultural Equity." *Parallélogramme* 19, no. 3 (Autumn 1993).

Anzuldua, Gloria. "To live in the Borderlands means you." In *Borderlands/La Frontera: The New Mestiza*. San Francisco: Spinsters/Aunt Lute, 1987.

Asad, Talal. "The Concept of Cultural Translation in British Social Anthropology." In *Writing Culture: The Poetics and Politics of Ethnography*, edited by James Clifford and George E. Marcus. Berkeley: University of California Press, 1986.

Bad Object-Choices, eds. *How do I Look: Queer Film and Video*. Seattle: Bay Press, 1991.

Baert, Renee. "Video in Canada: In Search of Authority." In *Vidéo*, edited by René Payant. Montréal: Artextes, 1986.

Balf, Ruth. *Kamloops: A History of the District up to 1914*. Kamloops: Kamloops Museum, 1981.

Bannerji, Himani. *The Dark Side of the Nation: Essays on Multiculturalism, Nationalism and Gender*. Toronto: Canadian Scholars' Press, 2000.

Beveridge, Karl. "Colonialist Chic or Radical Cheek?" *Centrefold* 14 (June/July 1979).

Bhabha, Homi K. "Signs Taken for Wonders: Questions of Ambivalence and Authority under a Tree Outside Delhi, May 1817." In *"Race," Writing and Difference*, edited by Henry Louis Gates, Jr. Chicago: University of Chicago Press, 1986.

Bhabha, Homi K. and Jonathan Rutherford. "The Third Space: Interview with Homi Bhabha." In *Identity and Consciousness: (Re)-presenting the Self*. Regina: Dunlop Art Gallery, 1991.

Birnie-Danzker, Jo-Anne. "West Coast Performance: Praxis without Ideology?" In *Living Art Vancouver*. Vancouver: Western Front/Pumps/Video In, 1979.

Brand, Dionne. "Notes to Structuring the Text and the Craft of Writing." *Front* 6, no. 1 (September/October 1994).

Bronson, A. A. "Pablum for the Pablum Eaters." In *Video by Artists*, edited by Peggy Gale. Toronto: Art Metropole, 1976.

Brown, Dee. *Bury My Heart at Wounded Knee*. New York: Henry Holt, 1970.

Brown, John Epes. *The Sacred Pipe: Black Elk's Account of the Seven Rites of the Oglala Sioux*. New York: Penguin Books, 1971.

Browne, E.G. *A Literary History of Persia*. Cambridge: Cambridge University Press, 1969.

Burstyn, Varda. "The Wrong Sex." *Canadian Forum* no. 741 (August/September 1984).

Chan, Kwok B. and Denise Helly. "Introduction to the special issue: Coping with Racism: The Chinese Experience in Canada." *Canadian Ethnic Studies* XIX, no. 3 (1987).

Chinook Winds: Aboriginal Dance Project. Banff: The Banff Centre and 7th Generation Books, 1997.

Churchill, Ward. "The Earth is Our Mother: Struggles for American Indian Land and Liberation in the Contemporary United States." In *When Predator Came: Notes from the Struggle for American Indian Liberation*. Littleton, Col.: Aigis Publications, 1995.

Daniel, Barbara. "The Balance of Convenience." *Parallélogramme* 9 no. 5 (Summer 1984).

Dawes, Kwame. "Negotiating Difference: About Face, About Frame Coalition formed at Historic Banff Meeting." *Parallélogramme* 18, no. 2 (Autumn 1992).

Deloria Jr., Vine. *For This Land: Writings on Religion in America*. New York: Routledge, 1999.

Diamond, Sara. "Clear about Confused." *Video Guide* 6, no. 2 (March 1984).

——. "Paul Wong Talks to Video Guide about the Making of 'Confused.'" *Video Guide* 6, no. 2 (March 1984).

——. "Daring Documents: The Practical Aesthetics of Early Vancouver Video." In *Vancouver Anthology: The Institutional Politics of Art*, edited by Stan Douglas. Vancouver: Talonbooks, 1991.

Duchaine, Andrée. "Fifth Network, Cinquième Réseau." *Parachute* 13 (Winter/Hiver 1978).

Ferguson, Russell, Martha Gever, Trinh T. Minh-ha, Cornel West, eds. *Out There: Marginalization and Contemporary Cultures*. New York: The New Museum of Contemporary Art and MIT Press, 1991.

Fernie, Lynne. "Editorial: Anti-Racism in the Arts." *Parallélogramme* 19, no. 3 (Autumn 1993).

Fung, Richard. "Everyday People." *Fuse* 13, 1/2 (Fall 1989).

——. "Multiculturalism Reconsidered." In *Yellow Peril: Reconsidered*, edited by Paul Wong. Vancouver: On Edge, 1990.

——. "Working Through Cultural Appropriation." *Fuse* vol. XVI nos. 5/6 (1993)

——. "Seeing Yellow: Asian Identities in Film and Video." In *The State of Asian America, Activism and Resistance in the 1990s*, edited by Karin Aguilar-San Juan. Boston: South End Press, 1994.

——. "Conference Calls: Race as Special Event." *Take One* 5 (Summer 1994)

——. "The Trouble with 'Asians.'" In *Negotiating Lesbian and Gay Subjects*, edited by Monika Dorenkamp and Richard Henke. New York and London: Routledge, 1995.

Fusco, Coco. *English is Broken Here: Notes on Cultural Fusion in the Americas*. New York: New Press, 1995.

Gagnon, Monika Kin. "Work in Progress: Canadian Women in the Visual Arts, 1975–1987." In *Work in Progress: Building Feminist Culture*, edited by Rhea Tregebov. Toronto: The Women's Press, 1987.

——. "A Resource to Dialogue: Some Notes from Inside the Caucus." *Parallélogramme* 18, no. 3 (Winter 1992–93)

——. "Al Fannanah 'l Rassamah: Jamelie Hassan." In *Sightlines*, edited by Jessica Bradley and Lesley Johnstone. Montréal: Artextes, 1994.

——. "Landmarks and Landmines." *Front* 6, no. 1 (September/October 1994)

Gagnon, Monika Kin and Scott McFarlane. "Writing Thru Race." *Parallélogramme* 20, no. 2 (Autumn 1994).

Gale, Peggy. "Video Art in Canada: Four Worlds." *Studio International* (May/June 1976).

Garber, Marjorie. "The Occidental Tourist: M. Butterfly and the Scandal of Transvestism." In *Nationalisms and Sexualities*, edited by Andrew Parker, Mary Russo, Doris Sommer and Patricia Yaeger. New York: Routledge, 1992.

Gever, Martha, John Greyson and Pratibha Parmar, eds. *Queer Looks: Perspectives on Gay Film and Video*. New York: Routledge/Toronto: Between the Lines, 1993.

Giroux, Henry A. "Living Dangerously: Identity Politics and the New Cultural Racism." In *Between Borders: Pedagogy and the Politics of Cultural Studies*, edited by Henry A. Giroux and Peter McLaren. New York: Routledge, 1994.

Goldberg, Michael. "Paul Wong Interviewed by Michael Goldberg." *Centrefold* 2, no. 5 (June 1978).

Greenblatt, Stephen. *Marvelous Possessions*. Chicago: University of Chicago, 1990.

Greyson, John. "Initial Response." *Centrefold* 15 (June/July 1979).

Guest, Tim. "Intolerance (The Trouble with Social Realism)." *Parallélogramme* 8, no. 1 (October/November 1982).

Gupta, Sunil, ed. *Disrupted Borders: An Intervention in Definitions of Boundaries*. London: Rivers Oram Press, 1993.

Hassan, Jamelie and Jamila Ismail. *The Jamelie/Jamila Project*. Vancouver: Presentation House, 1993.

Hassan, Marwan. "Children and Social Space: Why Did Derrida Say No." In *Identity Transfers: Jamelie Hassan and Sarinder Dhaliwal*. Peterborough: The Art Gallery of Peterborough, 1993.

——. "wordS and sWord: An Anagram of Appropriation[1]." *Fuse* 16, nos. 5/6 (July/August 1993).

Hazen-Hammond, Susan. *Timelines of Native American History*. New York: Perigree, 1997.

Hill, Richard. "One Part per Million, White Appropriation and Native Voices." *Fuse* vol. 15, no. 2 (Winter 1992).

Irigaray, Luce. "When Our Lips Speak Together." In *This Sex Which is Not One*. Translated by Catherine Porter. Ithaca: Cornell University Press, 1985.

Ismail, Jamila. "Oolemma." Special issue, "Transporting the Emporium: Hong Kong Art and Writing Through the Ends of Time," *West coast line* 21 (Winter 1996/97).

Kilpatrick, Jacquelyn. *Celluloid Indians: Native Americans and Film*. Lincoln and London: University of Nebraska Press, 1999.

Knights, Karen. "Sculpting the Deficient Flesh: Mainstreet, Body Culture and the Video Scalpel." In *Making Video "In"*, edited by Jennifer Abbott. Vancouver: Video In, 2000.

Kobayashi, Audrey. "Multiculturalism: Representing a Canadian Institution." In *Place/Culture/Representation*, edited by James Duncan and David Ley. New York: Routledge, 1993.

L'Hirondelle, Cheryl. "Energizing Anti-Racist Strategies in the Artist-Run Network: Pre-Minquon Panchayat in Toronto." *Parallélogramme* 19, no. 1 (Summer 1993).

———. "It's a Cultural Thing." *Parallélogramme* 19, no. 3 (Autumn 1993).

L'Hirondelle, Cheryl and Kevin Walkes. "Minquon Panchayat Update: It's a Cultural Thing." *Parallélogramme* 19, no. 2 (Fall 1993).

Lai, Larissa. "Doubling Identities." *Kinesis*. (June 1993).

———. "The Site of Memory." In *Paul Wong* (Exhibition Catalogue). Banff: Walter Phillips Gallery, 1993.

Laiwan. "It's a Cultural Clash." *Angles* (October 1993).

Lame Deer, John Fire (told by). "The White Buffalo Woman." In *American Indian Myths and Legends*, edited by Richard Erdoes and Alfonso Ortiz. New York: Pantheon Books, 1984.

Lippard, Lucy R. *Mixed Blessings: New Art in a Multicultural America*. New York: Pantheon Books, 1990.

———. *The Pink Glass Swan: Selected Feminist Essays on Art*. New York: The New Press, 1995.

Lord, Audre. "The Master's Tools Will Not Dismantle the Master's House." In *Sister Outsider*. Freedom, California: The Crossing Press, 1984.

McFarlane, Scott. "The Haunt of Race: Canada's Multiculturalism Act, the Politics of Incorporation, and Writing Thru Race." *Fuse* 18, no. 3 (Spring 1995).

Marchessault, Janine, ed. *Mirror Machine: Video and Identity*. Toronto/Montreal: YYZ Books and Centre for Research on Canadian Cultural Industries and Institutions, 1995.

Maskegon-Iskwew, Ahasiw. "Parallel Tracks" Preconference panel discussion for "Writing Thru Race," Vancouver, 28 March, 1994.

Mathur, Ashok. "Troublemakers in training: notes towards anti-racist (art) activism and taking it to the streets. Calgary." In *Taking It to the Streets*. Toronto: SAVAC, 1998.

Medicine, Beatrice. "Lakota Views of 'Art' and Artist Expression," *Ablakela* (CD-ROM), (Vancouver: grunt gallery, forthcoming).

Memmi, Albert. *Racism*. Minneapolis: University of Minnesota Press, 2000.

Mercer, Kobena. "Black Art and the Burden of Representation," *Third Text* 10 (Spring 1990).

MONIKA KIN GAGNON

——. *Welcome to the Jungle: New Positions in Cultural Studies*. New York: Routledge, 1994.

Miki, Roy. *Broken Entries: Race, Subjectivity, Writing*. Toronto: Mercury Press, 1998.

Minquon Panchayat, "The Journey Has Begun...." *Parallélogramme* 18, no. 4 (Spring 1993).

Miyazaki, Koichiro. "The Story of a Diehard." In *Stone Voices*, edited by Keibo Oiwa. Montreal: Véhicule Press, 1991.

Mootoo, Shani. *Out on Main Street*. Vancouver: Press Gang, 1994.

Nourbese Philip, M. *Frontiers: Essays and Writings on Racism and Culture*. Stratford, Ontario: Mercury Press, 1992.

Pasco, Duane. *Klahowya: A Handbook for Learning Chinook Jargon*. Washington: Poulsbo, 1990.

Pollack, Nancy. "Visibly out of focus." *Kinesis* (June 1991).

Pollock, Griselda. *Vision and Difference: Femininity, Feminism and the Histories of Art*. New York: Routledge, 1988.

Pratt, Marie Louise. *Imperial Eyes: Travel Writing and Transculturation*. London: Routledge, 1992.

Radice, Betty. *Who's Who in the Ancient World*. New York: Penguin, 1987.

Read, Alan, ed. *The Fact of Blackness: Frantz Fanon and Visual Representation*. London: Institute of Contemporary Arts and Institute of International Visual Arts, 1996.

Robertson, Clive. "Fifth Network, Cinquième Réseau." *Centrefold* 2, no. 6 (Sept. 1978).

Rosler, Martha. "Video: Shedding the Utopian Moment." In *Illuminating Video*, edited by Doug Hall and Sally Jo Fifer. New York: Aperture and Bay Area Video Coalition, 1990.

Rushing III, W. Jackson, ed. *Native American Art in the Twentieth Century*. New York: Routledge, 1999.

Sage, Elspeth. "Ethics and Art." *Parallélogramme* 12, no. 4 (April/May 1987).

Scott, F.R. "All the Spikes But the Last." In *Poets Between the Wars*, edited by Milton Wilson. Toronto: McClelland and Stewart Ltd., 1969.

Shah, Idries. "Working with the Story." In *The Sufi Mystery*, edited by N.P. Archer. London: Octagon Press, 1980.

Shaw, George Coombs. *The Chinook Jargon and How To Use It: A Complete and Exhaustive Lexicon of the Oldest Trade Language of the American Continent*. Seattle: Rainier Printing Co., 1909.

Shohat, Ella, ed. *Talking Visions: Multicultural Feminism in a Transnational Age*. New York: New Museum of Contemporary Art and The MIT Press, 1998.

Shohat, Ella and Robert Stam. *Unthinking Eurocentrism: Multiculturalism and the Media*. New York: Routledge, 1994.

Shum, Mina. "About Face, About Frame." *Fuse* vol. 16, no. 1 (Fall 1992).

Spivak, Gayatri Chakravorty. "Inscriptions of Truth to Size." In *Inscription*. Regina: Dunlop Art Gallery, 1990.

Thomas, Edward Harper. *Chinook: A History and Dictionary of the Northwest Coast Trade Jargon.* Portland, Oregon: Binfords and Mort, 1935.

Todd, Loretta. "Notes on Appropriation." *Parallélogramme* 16, no. 1 (Summer 1990).

Townsend-Gault, Charlotte. "Hot Dogs, a Ball Gown, Adobe and Words: The Modes and Materials of Identity." In *Native American Art in the Twentieth Century*, edited by W. Jackson Rushing III. New York: Routledge, 1999.

Tregebov, Rhea, ed. *Work in Progress: Building Feminist Culture.* Toronto: The Women's Press, 1987.

Trinh, Minh-ha, T. "Bold Omissions and Minute Depictions." In *Moving the Image: Independent Asian Pacific American Media Arts.* Los Angeles: UCLA Asian American Studies Centre and Visual Communications, Southern California Asian American Studies Central, Inc., 1991.

——. "The World as Foreign Land." In *When the Moon Waxes Red*. New York: Routledge, 1991.

Tsang, Henry. "Self Not Whole: In Search of a Cultural Centre." In *Self Not Whole: Cultural Identity and Chinese-Canadian Artists in Vancouver*. Vancouver: Chinese Cultural Centre, 1991.

Walker, James R. *Lakota Belief and Ritual*, edited by Raymond J. DeMallie and Elaine A. Jahner. Lincoln, Nebraska: University of Nebraska Press, 1980.

West, Cornel. "The New Cultural Politics of Difference." In *Out There*, edited by Russell Ferguson, Martha Gever, Trinh T. Minh-ha and Cornel West. New York: New Museum of Contemporary Art and MIT Press, 1991.

——. "Learning to Talk of Race." *The New York Times Magazine*, 2 August 1992.

Wittig, Monique. *Les Guérillères*, translated by David LeVay. New York: Avon, 1973.

Wong, Paul. *Yellow Peril: Reconsidered* (Exhibition Catalogue). Vancouver: On Edge, 1990.

Writing Thru Race Conference: Final Report. Toronto: Writers' Union of Canada, 1995.

Yoon, Jin-me. *between departure and arrival* (Exhibition Catalogue). Vancouver: The Western Front, 1999.

Young, Robert J.C. *Colonial Desire: Hybridity in Theory, Culture and Race.* New York: Routledge, 1995.

Yourcenar, Marguerite. *Fires.* New York: Farrar, Strauss and Giroux, 1981.

Yuen, Sharyn. "Artist's Statement." In *Self Not Whole*. Vancouver: Chinese Cultural Centre, 1992.

Index

MONIKA KIN GAGNON

Publisher Acknowledgments

On behalf of the Board and Staff of Artspeak, I would like to thank the individuals and organizations that have, in a convergence of effort, skill, and support, contributed to this publication. *Other Conundrums* marks the exhibitions of new work by Dana Claxton at Artspeak Gallery and the Kamloops Art Gallery and brings together a collection of articles and essays by Monika Kin Gagnon. This collection serves to document a range of flashpoints, debates, charged exchanges, and sustained dialogues crucial to the understanding of the visual arts over the eighties and nineties. I would like to thank Monika for her steady commitment to art, scholarship, and other forms of activism that grapple with the varied paradoxes of identity in contemporary Canadian culture. Dana Claxton and the many artists cited in this book continue to challenge, haunt, tease, and stretch the imagination in the complexity of such conundrums and I would like to thank them for their persistence. It has been a distinct pleasure to take part in the planning and production of this book with Brian Lam of Arsenal Pulp Press and Susan Edelstein of the Kamloops Art Gallery. Their experience and collaborative spirit are much appreciated. Many thanks are due to Larissa Lai for her forward, to Roberta Batchelor for her visual design, to Kim Clarke for installation photography and to Kathleen Ritter's editorial assistance. Artspeak was supported in this endeavour by The Canada Council for the Arts through the Exhibition/Dissemination Assistance Program and we are grateful for the ongoing support of The Canada Council for the Arts, the Province of British Columbia through the BC Arts Council, the City of Vancouver, the Vancouver Foundation, the British Columbia Gaming Commission, Heritage Canada, our Board of Directors, volunteers and our members.

— Lorna Brown, Director/Curator
Artspeak Gallery

My initial involvement in this project began when I was working as Director/Curator of Artspeak Gallery. Despite my change of locations I was pleased to continue working on this collaboration, and to include the Kamloops Art Gallery as a contributor.

I would like to thank Monika Kin Gagnon for her work on this book project and her rigorous commitment to engaging with issues of race and culture. Over the years Monika's contributions have helped to illuminate the work of numerous Canadian artists, extending the boundaries and shape of this discussion.

I wish to express my genuine thanks to Brian Lam of Arsenal Pulp Press who worked so diligently to bring this book together. Moreover, to Lorna Brown, the incumbent Director/Curator of Artspeak Gallery, for taking on this project with great enthusiasm and commitment to its conclusion.

A project of this magnitude requires the expertise and collaboration of many individuals, and I am grateful to all those who helped transform this idea into a tangible reality. Thanks to Roberta Batchelor and Brian Morgan, Kim Clarke, Dana Claxton, Kathleen Ritter, Nancy Shaw and Beverley Clayton. A special expression of appreciation goes to Jann Bailey, Director of the Kamloops Art Gallery for her support and enthusiasm, the Board of Directors and the Staff at the KAG. Thanks to the Museums Assistance Program through the Department of Canadian Heritage for supporting this project.

The Kamloops Art Gallery gratefully acknowledges the financial support of The Canada Council for the Arts, the Province of British Columbia through the British Columbia Arts Council, the City of Kamloops, the Government of Canada Human Resources Development, corporate donations and sponsorships, foundation grants, general donations and our members.

<div align="right">

— Susan Edelstein, Curator
Kamloops Art Gallery

</div>

About the author

MONIKA KIN GAGNON is a writer, teacher, and curator whose work has been published in numerous books, including *topographies: aspects of recent B.C. art*; *Fluid Exchanges: Artists and Critics in the AIDS Crisis*, and *Ghosts in the Machine: Women and Cultural Policy in Canada and Australia*, as well as in many magazines, journals, and exhibition catalogues. She has a doctorate in Communications Studies from Simon Fraser University in Burnaby, B.C., and a Masters degree from York University in Toronto. She lives in Montréal, where she currently teaches Communications Studies at Concordia University.